— Remembering —

Old Abington

REMEMBERING
Old Abington

THE COLLECTED WRITINGS OF
MARTHA CAMPBELL

EDITED BY DONALD CANN & JOHN GALLUZZO

Charleston · London

History
PRESS

Published by The History Press
Charleston, SC 29403
www.historypress.net

First published 2008

Manufactured in the United Kingdom

ISBN 978.1.59629.390.8

Library of Congress Cataloging-in-Publication Data

Campbell, Martha G.
Remembering old Abington : the collected writings of Martha Campbell /
edited by Donald Cann and John J. Galluzzo.
p. cm.
Columns originally published in the Rockland standard between 1965 and
1985.
ISBN-13: 978-1-59629-390-8 (alk. paper)
1. Abington (Mass.)--History. 2. Abington (Mass.)--Biography. I. Cann,
Donald. II. Galluzzo, John J. III. Title.
F74.A1C35 2007
974.4'82--dc22
 2007041970

Dedicated to all lovers of Old Abington history.

Contents

Acknowledgements

The editors of this book really deserve no credit at all for what you are about to read. We simply picked out our favorite Martha Campbell stories—from the nine hundred she published in her local newspaper—retyped them and sent them off to press. All of the credit for the text of the book must go directly to the late Martha Campbell.

There were others, though, who saw the value of such a project and who helped the editors along their way. First, Martha's husband, Colin Campbell, graciously agreed to consolidate the rights to republish her works under the umbrella of the Historical Society of Old Abington, an organization Martha heartily supported. Second, the Historical Society of Old Abington, now under the able leadership of Malcolm Whiting, has granted the editors the right to undertake this project. Third, the board and staff at the Dyer Memorial Library have helped with the location of appropriate imagery and other information pertaining to the book. Both entities have been of definite and willing help to both editors in the past, and will no doubt be so in the future. The towns of Abington, Rockland and Whitman are blessed by their presence.

The editors, as usual, would like to thank our families for their patience and support as we tackled yet another book together—our seventh joint venture. Mostly, though, we'd like to thank the innumerable people who over the years have contributed to the preservation of Old Abington's history through artifact donations, oral history and more. Martha regularly thanked them in her column, so we feel confident in offering thanks on her behalf to those people who continue to share their hometown history with generations to come. We, as local historians, are nothing without the documentation and memories of events of the people who were there.

The authors are also indebted to the following people for imagery, historical knowledge or other support: Sarah Corbitt, editor in chief, MPG Newspapers; Kate E. Kelly of Abington; Carole Mooney, formerly of

Rockland; the selectmen of the Town of Rockland; the First Congregational Church of Rockland; and Dean Sargent and Helen Keeler, both of Rockland.

As the material in this book was originally published over a thirty-year period that ended seventeen years ago, new historical evidence may have come to light that alters our current view of the past. The editors have tried to catch any such changes to keep Martha's work as up-to-date as possible. Thus, if there are any errors in the book, please blame us, not her.

Introduction

When historian Martha Campbell spoke, it was quite evident that she was from Tennessee. Her research and writing was about Plymouth County, Massachusetts. Abington, Rockland and Whitman—the three towns that once made up the colonial town of Abington, Massachusetts, established in 1712 and split into three separate towns in the late nineteenth century—are the subject matter of the articles in this volume. Martha wrote a weekly column called "The Research Reporter" for the *Rockland Standard*. The first one appeared on September 2, 1965, and the last one, numbered 900, on March 6, 1985.

She was born as Martha Geistman in Nashville on March 2, 1907. Martha's education consisted of a journey from one-room schools to a master's degree in educational psychology and art education. She used her education to teach in junior high school and college.

During World War II, Martha worked in New York as a civilian statistical analyst for the U.S. Army. There she met Colin Campbell, her future husband. After the war the couple moved to Abington, Massachusetts. When they purchased land on Plymouth Street to build a home designed by Colin, Martha became interested in the history of the land they had purchased for their house. This curiosity led to an adventure in research of Old Abington and Plymouth County. Martha served the Historical Society of Old Abington as its curator for twenty-five years.

During Martha's time as curator, she supervised the transcription of the Cyrus Nash papers. Nash, crippled from a fall, was not able to work. He lived in Abington in the early part of the nineteenth century and recorded the daily events of the town for fifty years. His papers, housed at the Dyer Memorial Library, number to three thousand pages. Nash used any paper that was available, big or small. His handwriting was terrible and he wrote in an antiquated style. Martha became an expert in translating and deciphering Nash's old, "period" style of handwriting. She taught others and gave lectures on what she had learned and methods of translation.

Introduction

Plymouth County Commissioner Kevin Donovan contacted Martha about becoming Plymouth County's archivist in 1987. Martha took the position and worked until 1993. She organized the earliest records and documents, beginning with the county's first years, 1620 to 1685. It was in 1865 that the colony government became a county government. What could have been described as a mess of deteriorating and unreadable original colonial documents were preserved, transcribed and ordered so researchers and the general public could find and read them. Amongst the collection were records that came from England on the *Mayflower*, deeds, wills, judicial, church and military records, as well as some Native American records.

If Martha did nothing else, her work for Plymouth would stand alone as a great achievement, but she went on to lecture and complete more research as well as publish more articles, pamphlets and books. Among these publications are a history of the schools of Old Abington, Abington's history during the American Revolution and a history of the Abington Savings Bank for its hundredth birthday. She also wrote extensively on the Native Americans in and around Plymouth County and, with Dr. George Whiting, produced three volumes of the vital records of Abington from 1850 to 1950.

Martha donated the money she earned from the *Rockland Standard* column in order to endow the annual historical essay contest of the Historical Society of Old Abington. Thanks to this gift, the work of the Old Abington Historical Society continues and is available to the public. Also, Martha served on Abington's Historical Commission for ten years and completed the research for the historical architectural survey of Abington

Martha Campbell made a large contribution to the area's history. Her research and promotion of local history leaves all area citizens indebted to her. We hope this volume gives new and old readers the opportunity to enjoy and learn about their towns.

Information for this introduction was obtained from Carole Mooney, Martha's editor at the *Rockland Standard*, and Dr. George L. Whiting's speech at Martha's ninetieth-birthday celebration held March 2, 1997. Both Dr. Whiting and Carole were Martha's friends as well as colleagues.

Old Abington, in a Nutshell

The original township of Abington included what are now not only Abington, but also Rockland and most of Whitman. It stretched east and west from Accord Pond near Queen Ann's corner on Route 3 to a point in D.W. Field Park in present-day Brockton. From north to south, it lay between the Abington-Weymouth town line and a point near the Whitman-Hanson Regional High School on Route 27.

The area was first opened up in the 1660s when settlers from Weymouth began buying the land grants here and clearing them for homesteads. Thus, the early settlers came from Massachusetts Bay Colony, but the land here was a part of Plymouth Colony.

The land grants were parcels that had been given out by the General Court of Plymouth Colony back when this was all still common land, as pay to local individuals who had performed public service for the colony. These services were likely to be clerical, surveying, treating with the Native Americans or similar routine jobs. None of the original grantees made use of their land here except to sell it to people of Massachusetts Bay Colony elsewhere.

There were eighteen land grants ranging in size from fifty acres to two hundred acres or larger, and all were attached, for access, to the "Satucket Path," an American Indian trail that led from Wessagusset Beach in North Weymouth to the head of the Satucket River in what is now called Robin's Pond in East Bridgewater. Adams and Washington Streets in modern Abington and Whitman approximate that path today.

Most of what is now Abington, and also modern Rockland, originated as these land grants.

The first settler was Andrew Ford, who came from Weymouth and established a home on the Satucket Path as early as about 1668. He was

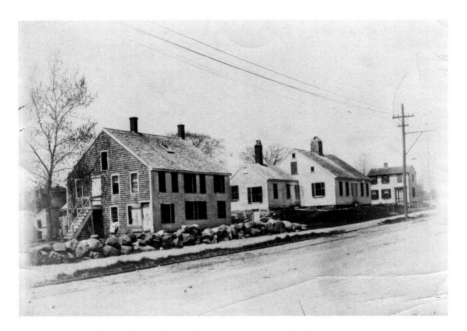

Some of the earliest settlers of East Abington came over the Weymouth line to houses like this one, which once stood at 1180 Union Street. Here, Thomas Hunt started his shoemaking business in town. *Courtesy of the Historical Society of East Abington.*

run out during King Philip's (Indian) War of 1675 and '76, but he came back after hostilities ceased. His home stood several hundred yards back from what is now the junction of Adams and Washington Streets in North Abington. A tiny triangular park in the junction memorializes him.

Several of Andrew Ford's brothers, as well as other families, began coming in and opening up the land in the next few decades. The second family was the Chards, also of Weymouth, who settled over the town line into what is now Whitman. Soon, sawmills were also erected on the little streams in what are now Abington, Whitman, Rockland and West Abington, and they formed the center for small, individual settlements that foreshadowed the eventual division of the large township.

By 1706, there were about twenty families in residence along the length of the Satucket Path, plus the lanes leading over to the mills in the Centre and the South (now Whitman), and the people felt that the time had come to be incorporated as a township that could govern itself and maintain its own church. They were having to travel to Bridgewater or Weymouth, or even to Boston, to be married and to have their babies baptized.

Six years were to pass before the settlers could secure a minister who would settle in their midst and head the church.

They finally came to terms with young Reverend Samuel Browne of Newbury, a recent graduate of Harvard College. With this last prerequisite satisfied, the original Township of Abington was incorporated on June 10, 1712.

#670: "Thumbnail Overview of Abington History," July 17, 1980

The oldest house still standing in Abington is the back part of 770 Washington Street, a full two-story dwelling erected by Ensign Andrew Ford Jr.—son of the first settler—as his "new" house. The back part with its central chimney is precisely dated as 1735 by an old manuscript journal now in the archives of the Historical Society of Old Abington. The brick-front ell, which was attached in 1804, furnished additional rooms for the inn that had been opened by the Howe family who had purchased the property from the Fords. The inn was a stop on the Boston–New Bedford network of stagecoach lines.

There was also a store in one of the downstairs front rooms, and the town's first post office was established here in 1812. Mail was brought in and out by coach, but there was no local delivery. People had to stop by and ask if they had received anything.

On March 19, 1770, the townspeople of Abington voted a "position paper," stating their attitude regarding the British parliament's encroachment on their rights as free Englishmen. This set of sixteen resolves was drawn up by a committee of seven men, of whom Joseph Greenleaf Esq. was undoubtedly the chairman and principal author of the document.

Their proposed paper was unanimously accepted by the townspeople and a copy was immediately forwarded to the Committee of Inspection in Boston. The Boston leaders of the Revolutionary movement sent it to the editor of the *Boston Gazette* where it came out in print on Monday, April 2, exactly four days before the better-known Suffolk Resolves and Plymouth County Resolves were drawn up.

Although all of these resolves make practically the same statements, the two county groups (especially Suffolk County, which included the leaders of the Revolutionary movement in Boston) were in better position to make their action known than was the small country town of Abington. Thus, the Abington Resolves were almost forgotten in history, despite the fact that they were the first; that they were quoted in Boston's leading newspaper of the day and dubbed "Noble Resolves"; and that they were authored by Joseph Greenleaf, who later became editor of the *Royal American* magazine

in Boston and also served on the subcommittee in Boston that drew up the Solemn League and Covenant to pursue the road toward independence from Britain.

The first written history of the town appeared in 1826 in a short article in a periodical publication called the *Collections of the Massachusetts Historical Society*.

In that paper, Mr. Samuel Davis, who was the author but was not a local man, remarked that an old gentleman here told him that the Native American name for the locality was *Manamooskeagin*, meaning "Land of Many Beavers," but that he (that is, Mr. Davis) could not verify that translation. Unfortunately, later authors repeated the erroneous translation without mentioning the qualifying doubt. Recent authorities in the Algonquian language have accurately translated the name as "Great Green Place of Shaking Grass," but errors in print die hard. It is hoped that, as time goes on, the correct meaning of the word will supersede the misinformation.

It is not the case that beavers were unavailable in this area in the early days. The Native American name for the town's principal streams perpetuates the fact that beavers were important in the ecology of the region. *Schumacastacut* (now "Beaver Brooke" on part of the boundary between Abington and Brockton) means "Beaver stream always dependable," and *Schumatuscacant* in the Centre translates as "Beaver stream with the Stepping-Over Place" due to the narrow place where travelers on the Satucket Path could get across the river. That "stepping-over place" was at the foot of the knoll where Andrew Ford established his home as the first settler of the territory. In fact, he built on a spot that the Native Americans had already cleared and used as a camp site for their wigwams.

Abington cannot boast of the best farmlands, and it was thus natural that the people would turn to industry. Shoemaking was introduced in 1794, encouraged by a dependable supply of leather available from its several tanners. At first, shoemaking was a cottage-type industry in which almost every family was engaged, but within one generation the first factory-type activity was introduced; that is, in the 1820s.

On August 1, 1846, a large gathering assembled in Island Grove Park for an all-day outdoor meeting. They were the abolitionists led by William Lloyd Garrison. A special train on the newly-built railroad had brought them down from Boston. This was the beginning of these famous "August First" meetings, which brought sometimes as many as ten thousand members and spectators who were agitating for the abolition of slavery in the Southern states.

The park was then owned by Ezekial Reed of 222 Centre Avenue, Abington, and he (knowing a good thing when he saw it) soon added an

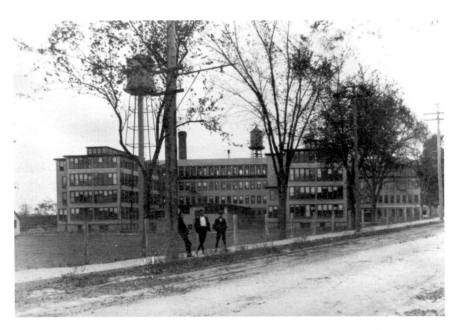

From meager beginnings in the shoe industry grew major factories, like Regal Shoe in Whitman. *Courtesy of the Historical Society of Old Abington.*

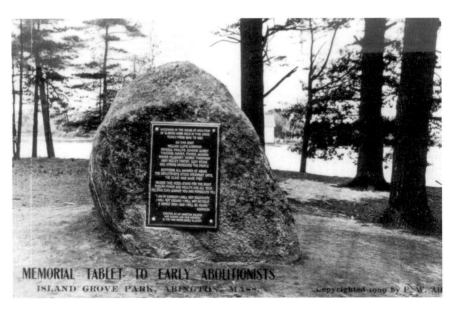

The serenity of Island Grove drew abolitionists to meet there annually in the years leading up to the Civil War. Years later, shoe manufacturer Moses N. Arnold commemorated their adherence to the abolitionist cause by placing this marker on the grounds. *Courtesy of the Dyer Memorial Library.*

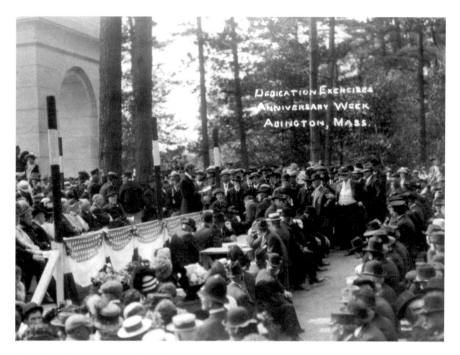

The 1912 Bicentennial celebration of the founding of Old Abington included the dedication of the soldiers and sailors memorial at Island Grove. *Courtesy of the Dyer Memorial Library.*

amusement area for the benefit of the crowds. There was a bowling alley, a dancing pavilion, an early form of carousel and assorted booths for food and drinks. Canoes were also available on the pond and could be hired by the hour. Canoe clubs continued to be popular here after the town took over the park, and old folks can remember regattas with as many as one hundred canoes entered in the events. Summer evenings were complete with band concerts and fireworks on special occasions.

#671: "THUMBNAIL OVERVIEW OF ABINGTON HISTORY," JULY 24, 1980

Let us go back to shoemaking in Old Abington.

By 1860, Old Abington was the richest town in Plymouth County. There were eighty-two shoe factories listed in the federal census that year. A shoe-sole sewing machine was introduced just in time for the area to secure government contracts for shoes to be furnished for the Union army in the Civil War.

Old Abington, in a Nutshell

It is almost impossible to realize now that in 1860 Abington vastly out-produced the tiny village that was then North Bridgewater, but now has become the city of Brockton. However, forces were soon at work to reverse this situation.

The outlying villages of East Abington (now Rockland) and South Abington (now Whitman) were outgrowing the Centre, and the time had come for the town to be divided or go onto a representative form of government. There was little to hold them together, other than geography, and their needs were no longer the same. They had already separated their religious societies into first, second and third parishes, and in addition, East Abington had organized itself into a fire district, which gave them further feeling of independence. The urge was there—all that was needed was a cause to fire the populace.

That cause presented itself when the Centre built an expensive new high school building costing twice the amount that the town as a whole had voted to be raised and appropriated. People of the East and South villages would be taxed their proportion to pay for the illegal overrun to complete the school—a school that their children couldn't even attend.

They rose in wrath and applied to be set off and incorporated as separate towns—Rockland in 1874 and what is now Whitman in 1875.

By chance, simultaneously during these years the shoemaking industry had begun to shift to the town of Brockton. There seems to have been no one reason for this shift unless it was that the leading manufacturers in the old township of Abington were approaching retirement age, while the leaders in the industry in Brockton were young and enthusiastic. The workmen and, indeed, the contracts gravitated toward their success.

So the combination—that is, the sudden shrinkage of Abington to one-third of its previous size, plus the gravitation of the workers and the jobs toward Brockton—resulted in Abington's no longer heading the list as the shoemaking center of Plymouth County.

Abington thus became a residential rather than an industrial town, although several shoe factories remained for a number of years. M.N. Arnold and L.A. Crossett in North Abington, and C.H. Alden of the Centre, who paid his employees in gold coins to honor the gold strike in the Yukon in 1897, continued until the time of the Great Depression of the 1930s.

It was back in August 1893 that the shameful, yet important, North Abington Riot took place. The riot only lasted an hour and a half but it put a law into the annals of jurisprudence of Massachusetts, and it put an end to the railroad corporations' growing notions that they were bigger than the law.

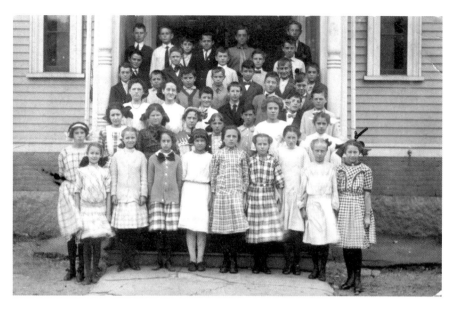

It is hard to believe it today, but the rift that led to the separation of East and South Abington from the Centre revolved around how much money the towns were willing to devote to educating their kids—like these students at the Adams School in 1911. *Courtesy of Kate Kelly.*

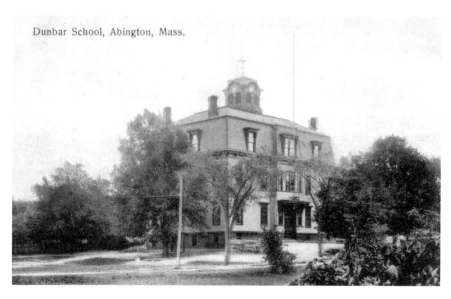

Known to the "divisionists" as the "great Mansard abomination," the Dunbar Street School was the building that caused all the trouble. *Courtesy of the Historical Society of Old Abington.*

Old Abington, in a Nutshell

The riot was a confrontation between the New York, New Haven & Hartford Railroad Corporation, known popularly as the "New Haven line," and the people of the Town of Abington. It was caused by the New Haven's refusal to allow the then new electric streetcar company to cross its tracks at North Avenue. All kinds of weapons were used—pickaxes, shovels, cobblestones, the fire hose and even guns. Blood was drawn and property was damaged during that hour and a half on August 16, 1893, and all because the railroad company refused to insert a "frog" in their tracks to allow the streetcars to cross. A frog was simply a section of track with grooves cut across it to allow the flanges of the streetcar's wheels to ride in them rather than having to bump up across.

After the shameful event, the town sued the railroad and the judgment was that the railroad officials were at fault. The corporation paid all damages and, in addition, five of their officials served time in the Plymouth County house of correction. How much cheaper it would have been, and how they could have avoided pain and embarrassment if they had only inserted the frog! But the early railroads had delusions of grandeur and they tried not to let anyone circumvent their decisions. They had to learn the hard way.

The North Abington Riot put an end to the encroaching autocracy of big corporations—especially railroad lines—nationwide.

Abingtonians have always been interested in their history. They have enthusiastically celebrated all their birthdays of magnitude, especially their Bicentennial in 1912 and their 250th anniversary in 1962.

In 1939, a group of dedicated preservationists from the three sections of the old township organized the Historical Society of Old Abington. The society, which has headquarters in the Dyer Memorial Library building, represents the modern jurisdictions of Abington, Rockland and Whitman.

Everybody here is interested in the fact that the first titles to property in our town originated as land grants from the General Court of Plymouth Colony; that the town was named for a titled English lady, that it was the scene of important early abolition meetings; that it was once the principal seat of shoemaking in Plymouth County; that it can claim the honor of being the only town a schoolhouse divided; that the selectmen and townspeople succeeded in forcing a great and rich railroad corporation to conform to the laws of the land; and most of all, that it is a fine place in which to live.

In 1975, the citizens of Abington activated their local historical commission as a branch of their town government. Since that date, the commission has been coordinating the study of the history of the town. An inventory of the important historic places in Abington is now on file in the Burton L. Wales Public Library and the Dyer Memorial Library on Centre Avenue.

Naming Old Abington

#365: "Abington was named for a lady,"
March 28, 1974

Abington was named to honor an English lady, Anne Venables-Bertie, wife of the Earl of Abingdon. We first made this statement back in 1962, after having made an in-depth study that eliminated all sorts of other possibilities while proving, at least to our satisfaction, that this theory is correct.

We believe that Joseph Dudley, royal governor of Massachusetts, selected the name, and the local settlers in this area who were "praying" to be set off as a separate town went along with his request. We are so sure of this that we do not even say "probably." We believe that all details of the story bear out the theory so consistently that we can state it as a fact.

Governor Dudley wished to honor the English lady to whom he felt especially obligated. Well he might have felt obliged, because she had clinched the Massachusetts governorship for him—the thing he probably wanted more than anything else in the world.

Joseph Dudley was not exactly an exponent of "making friends in order to influence people," to misquote a title to a book. He was, in fact, aristocratic and overly endowed with self-esteem. He had made a number of archenemies in his young adulthood as a budding politician, and he greatly desired to rise to a position where he could lord it over them. His father had been governor of the colony (although of a vastly different personality), and he wanted to be, too.

To this end, he went to England where he stayed off and on for twenty years, scheming always to be named royal governor of Massachusetts Bay Colony. Dr. Everett Kimball, associate professor of history at Smith College, made this point exceedingly clear in his *Public Life of Joseph Dudley*, published by Harvard University in 1911.

Naming Old Abington

A number of powerful persons in England acted as Dudley's patrons during his years there. Among them were Pembroke, Leicester, Rutland, Lexington and Sutton. Dudley honored all of them by naming towns in Massachusetts for them. But the first town he named was Abington, indicating that this title had the highest priority on his list. It might be noted, in passing, that another of Dudley's friends and patrons in England was one Blathwayt. Let us be thankful that this name was not forced upon a defenseless pioneer settlement in the New World.

Dudley actually secured his original appointment as governor from William III (popularly known as William of Orange), but before he could set sail for America, the king died. Realizing that his commission was then worthless, Dudley set about getting it confirmed by Queen Anne, who had succeeded William.

Dudley managed to reach Anne's ear within two weeks. He accomplished this incredible feat through his friend, Anne Venables-Bertie, Queen Anne's lady of the bedchamber and closest confidante. She was the wife of Montagu Bertie, Second Earl of Abingdon. Her husband was not a public figure; he is not even mentioned in the *Dictionary of English Biography*. He was the typical English "county" man who stayed at home and tended to his estates. His wife was the public figure in court circles.

Joseph Dudley's commission was confirmed under Queen Anne on April 1, 1702. This time he was ready. He took his oath of office before the Privy Council on April 12, and set sail for Boston the following day.

The first Massachusetts town to be created during Joseph Dudley's tenure was Brookline, which dates from November 13, 1705. Dudley apparently made no attempt to influence the choice of name. The applicants themselves came in with their own suggestion, having decided on Brookline rather than Muddy River to their credit. There were too many important men who had established estates there, outside the hustle and bustle of Boston, for Dudley to risk tangling with them so early in his incumbency.

But on July 4, 1706, when a small group of relatively unknown men from over the line into what had been Plymouth Colony (by then Plymouth County) came in with a request to be set off as a township, he had his opportunity, and we believe that he made it known that he desired the new town to be named Abingdon. They were told that they must first bring in a map.

Samuel Sewall noted in his diary on several occasions that Governor Dudley used highhanded methods in securing what he wanted and that he would throw himself into towering rages when he was crossed. How we wish Judge Sewall had made some reference to what happened in council meeting or in the general court on that July 4; or for that matter, what went on behind the scenes sometime between then and the following August 9. He would have saved us a lot of research.

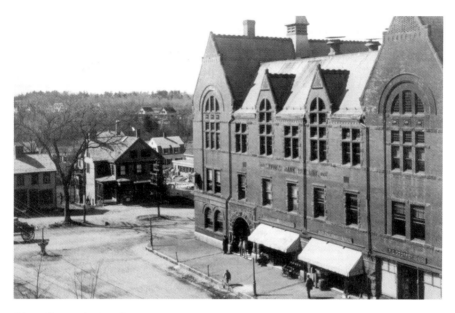

The Abington Savings Bank did not carry the town's name on its façade, but it became such a landmark that it was not easily mistaken for being in another community. *Courtesy of the Historical Society of Old Abington.*

On August 9, 1706, Samuel Thaxter of Hingham dated his drawing of the suggested boundaries for the proposed new town. On the map or "plat" he called the area Abbingdon, spelled with two *b*s and a *d*.

Abington was not incorporated until June 10, 1712, but its name had been selected and was used by those "in the know" during the intervening six years. In 1709, a deed was drawn up relative to a piece of property in a "Part of that Land petitioned to ye General Court for a Township called Abbingdon" (Plymouth County Deeds 14:102).

#370: "ROCKLAND SELECTED NAME BEFORE BECOMING A TOWN," MAY 2, 1974

Washington Reed, George B. Clapp and the other gentlemen of the East Village who sought to separate East Abington from the rest of the town have been described as "empire builders." They certainly were busy keeping their cause alive in 1872 and 1873.

The antidivisionists—those folks who hoped to keep Abington as it always had been—were equally busy. Flyers were hastily printed and handed out.

One, which bears no date but must have been devised in 1873, resorts to sarcasm. With serious mien, but with tongue-in-cheek tone, the author titled the sheet, "Why the Town of Abington Should Be Divided." It keeps referring to one East Abingtonian who was heading the move for the betterment of the town. Somebody wrote in pencil in the margin, "Boss Clapp."

Subscription lists, headed by a statement of position, were displayed in several stores in the Centre and customers were asked to sign. Most did.

Apparently the *South Abington Times* (weekly) was squaring off against the *Abington Standard* (weekly), which was based in the East Village. The *South's* press inserted quite a few derogatory remarks about the divisionists. Once, on April 30, 1873, the editor laconically commented that all the to-do in East Abington would die down if the village could only keep their "clap-trap shut." This, of course, was in reference to George B. Clapp, Washington Reed's partner in the boot making business.

But the antidivisionists were weakened by internal bickering. At one of their meetings, several of their "Committee of Twenty" resigned in high dudgeon and stalked out.

No such schism existed in the East, despite the fact that the leaders had about-faced and decided that they should pay their apportionment of the costs of building the expensive school in the Centre. They forged right ahead, backed almost unanimously by the citizens of the East ward.

Both the South Abingtonians and the East Abingtonians filed their petitions to be incorporated as separate towns on the same day, January 21, 1874, but the South's was recorded ahead of the East, for whatever significance that may have.

However, the South village's leaders had not been able to persuade the people of the Northville section of East Bridgewater that they should come in with them in becoming a new town. This, plus the realization that their petition would weaken the East's case, influenced them to withdraw their bill on January 28, 1874.

The East's petition was being hotly contested, of course, so a survey was made by the commonwealth's legislative committee and hearings were scheduled in Boston because of the evident protests.

The East hired the Honorable Ellis Morton to represent them, while the antidivisionists retained the Honorable Asa French. Both men spoke movingly, but when the bill came up for vote on March 4, 1874, the divisionists were triumphant. The bill passed with a majority of twenty-one votes in favor of incorporating a new town to be known as "Rockland."

The name "Rockland" had been selected by the citizens of the old East ward in a mass meeting back in January. In a preliminary poll of suggestions fifteen names were offered, as follows:

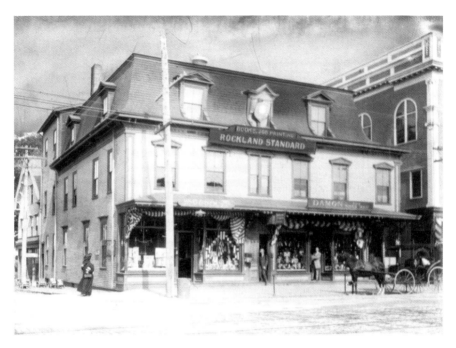

The *Rockland Standard*, however, did carry the name of the new town once it separated from its sister villages. *Courtesy of the Historical Society of Old Abington.*

Aberdeen, East Abington, Highland, Glenwood and Rock, 1 vote each; Albion, Benton and Commotion, 2 votes each; Alton and Underwood, 4 votes each; Standish, 5 votes; Aalberg, 17 votes; Andrew, 19 votes; Hatherly, 54 votes; Rockland, 115 votes.

In a final and official vote, the following results were tallied:

Rockland, 114 votes; Hatherly, 69 votes; Andrew, 31 votes; and scattering 19 votes.

Rockland was questioned by some as being too easily confused with the town of the same name in Maine, but the majority seemed to think it so geologically pertinent that other considerations didn't matter. Hatherly, of course, was promoted by local historians because the first land title to most of the town was a grant to Conihassett (now including Scituate Harbor). Andrew was suggested to honor the Honorable John Andrew, the Civil War governor of the commonwealth.

#372: "ABINGTON LOST THE SOUTH WARD IN 1875," MAY 16, 1974

The year 1874 was a great year for Rockland. All of the excitement and all of the enthusiastic optimism regarding the future were concentrated in the new town, which had just been cut off and created from the East ward of Old Abington.

But what was going on in the remainder of what had been the original township?

The selectmen of Abington reported in 1874:

> *Since our last report, a portion of what was the town of Abington has been incorporated into a new town, by the name of Rockland. This division has added to our labors this year.*

This is a sad little statement that only suggests the gloom that pervaded the Centre. Not only had they lost their East ward, but the South ward was still in ferment. They were still as anxious as ever to pull away and go it alone as an independent town.

The selectmen of Abington in 1874 were Jonathan Arnold of 499 Adams Street, Henry A. Noyes of 590 Washington Street in the Centre and Marcus Reed of 604 Washington Street in the South. Mr. Noyes was also the town clerk.

For the time being, the map of Abington showed a tall, skinny parcel of land encompassing what are now Abington proper and two-thirds of what is now Whitman.

The situation would remain like this for just a year, almost to the day. Then the South ward, too, would be cut off and we would no longer see "Major Marcus" Reed or any other Southerner seated in a public office in the Centre.

The people of the South ward, it will be remembered, had temporarily postponed their attempts to be cut off and incorporated. They felt very strongly that their new town—if and when it came into being—should approximate the old Second Parish that had been created back in 1808. This involved both the South ward of Old Abington and the "Auburnville" or "West Crook" section of East Bridgewater, and would thus combine what is the East End and the Centre of what is now Whitman together with the section that included the Toll House restaurant.

The citizens of the South were also still hopeful that they could bring in the Northville section of East Bridgewater. Northville included Washington Street as it runs southward beyond what we know as the Millet Farm today.

They had not been successful in influencing the Northville people in 1872 and 1873 that all their interests and activities were tied in with the south part of Abington rather than East Bridgewater Centre. One of the factors that was involved in the postponement of the South's campaign had been a desire for a little more time to try to bring Northville into line with their thinking.

But the extra year did them no good. They were unable to change the opinions of the Northville people in that year, or since. Northville is still a part of East Bridgewater.

So finally the citizens of the South ward of Old Abington, together with the Auburnville section of East Bridgewater applied to be incorporated as a new town. This time there was no fight. It was as though Abington Centre had given up and bowed to the inevitable.

The new town was incorporated on March 4, 1874, and named South Abington. It was to wear this cumbersome title for eleven years.

We don't know whether South Abingtonians truly resented the fact that their official name seemed to continue the implication that they were still a part of the mother town, or whether George A. Dorr, editor of the *South Abington Times*, merely resented the amount of space and printer's ink required to print the name on the heading of his weekly newspaper. Perhaps they were mostly piqued that Boston papers were constantly confusing the names and giving Abington credit for things happening in South Abington.

Anyhow, Dorr took the tack that South Abington was being put into the position of being a second-class town. Every time interest would die down he'd fire off another scathing article and hammer away on the notion that the town should change its name.

As in the case of all such situations, it took a dramatic incident to stir the people to action.

The town ordered a rock crusher, and when it was delivered, crated on a big flatbed truck, the crate was labeled, in large letters: "Made by the Lingerwood Manufacturing Co., for the Town of Abington."

That did it. The instigators had their dramatic incident and saw to it that the outrage prevailed long enough to get a bill presented to the state committee on towns, requesting that South Abington be allowed to change its name.

As usual, several names were submitted for the committee to ascertain that there would be no duplication of any other existing town in the state.

Several suggested names were chosen in a special meeting after permission for the change was granted in the legislature on March 5, 1886. Among them were Hatherly, Grandon and Whitman. We fail to see why Hatherly was suggested, other than the fact that Rockland had failed to honor the man who had held the first title to the land that was to make up

An independent community deserved a building of which to be proud, and as such, Whitman built this town hall. *Courtesy of the Historical Society of Old Abington.*

about two-thirds of their jurisdiction. No part of what is now Whitman was ever involved with Mr. Timothy Hatherly of Scituate.

Grandon was the middle name of Oliver G. Healy, a big contractor and land developer who opened up many of the house lots between Washington and Bedford Streets. Many citizens thought it was a foregone conclusion that Mr. Healy's name would get the vote. Mr. Barney Baldwin, who ran a horse-drawn coach from the South village to the station on the "pan-handle" tracks where this branch of the Old Colony railroad crossed South Washington Street, was so sure of the outcome that he had Grandon boldly painted on the side of a new rig, which he paraded around town the morning before the vote was taken.

Little did Mr. Baldwin know that two major figures who opposed Healy politically (Obed H. Ellis, a department store owner, and Elmer W. Noyes, a grocer) were getting out flyers urging the townspeople to honor the Whitman family who had settled in this section as early as 1767. Also involved in their argument was the fact that Whitman descendants had donated the tract of land now known as Whitman Park to the town.

As we all know, the name Whitman prevailed and was officially recorded by the state legislature on May 3, 1886.

Mr. Barney Baldwin learned not to count his chickens before they were hatched, and we can only draw the curtain of pity over Mr. Oliver G. Healy's reaction to the whole episode.

The Birth of the Shoe Industry

#79: "Shoemaking was Introduced Here by Hunt," July 12, 1967

Thomas Hunt, second child of Thomas and Experience (Thayer) Hunt, was the man who is usually credited with introducing "the gentle art of shoemaking" as an industry into southeastern Massachusetts. He rose to become a captain in the local militia and married, in 1795, Susanna Pool, daughter of Captain Joseph and Mehitable (Jackson) Pool of Abington Centre. He purchased the old, burned-out place—built by Gideon Hersey, and later home to Attorney Joseph Greenleaf then Daniel Reed III—on what is now the corner of Plymouth and Central Streets, diagonally across from the St. Bridget's property in Abington. Captain Thomas Hunt built the house that now stands on the corner, numbered 484 Plymouth Street.

Old Mr. Benjamin Hobart tells in a footnote on page 151 in his *History of Abington* how Thomas Hunt and his brothers started the shoemaking industry in Old Abington:

> *The shoe business was introduced into Abington about the year 1793 by Capt. Thomas Hunt, son of Thomas Hunt, who came from Weymouth about 1770, and located in what is now called East Abington, near the Weymouth line.*
>
> *There being a large number of sons in the family, it occurred to them that their hard, sterile farm would not afford sufficient remuneration for all; and Thomas, being the oldest, thought he would strike out and learn the art of making sale-shoes, thinking probably, that after a while it might become a business of considerable importance.*

Most of the shoemakers of that day were in the habit of going to houses of their customers and making up a stock of shoes for their families. This they called "whipping the cat."

The Birth of the Shoe Industry

We've long had the notion that this phrase, "whipping the cat," might have derived from the whipping motion made in pulling gut thread through the awl-punched holes as the upper and sole were hand sewn together. But to continue with the Hobart quotation:

> *The sale-shoe business had been started about this time in Quincy, by a Mr. Webb. It being arranged for Thomas to go to Quincy, he gave an invitation to one of his two young friends, by the name of Paine, who lived in Weymouth, to accompany him. At Quincy they learned the trade of making sale-shoes, and, in due time, returned home, prepared to teach others.*
>
> *Mr. Hunt commenced business in a small way. To get workmen he was obliged to take young men and teach them the trade. He had six brothers, who subsequently became shoemakers, and several of them did quite a large business in manufacturing shoes for that day.*
>
> *About that time Colonel David Gloyd, a tanner who lived in what is now called North Abington, thought he could manufacture sale-shoes to an advantage. He applied to Captain Hunt to take the charge of the business and get it started. Captain Hunt consented to do this, and when he had accomplished the object, he left Gloyd, and commenced business again on his own account.*
>
> *In the absence of railroad accommodation for transportation, they used the more primitive way of packing the shoes in large saddle-bags, and placing them on the old family horse, mounting the nag, and trudging off to Boston, returning thence in due time with two or three sides of sole leather in one side of the bags, and, in the other, upper stock, and perhaps some small articles for family use. So things went on increasing as fast as the young men could be instructed, till from these small beginnings the shoe trade of the town amounts to millions of dollars annually.*

It would appear that the above story of the introduction of shoemaking into Abington must have been told to old Mr. Hobart by Colonel Thomas Jefferson Hunt, son of Captain Thomas Hunt, because of its authenticity of detail, and we read in Mr. Hobart's further discussion of shoemaking that Colonel Hunt did give him information. This is the Colonel Hunt for whom the residential section was named in Abington, after it was opened up in his former land.

There is an interesting controversy about who first introduced shoemaking as an industry. The Payn family also claims to have been the pioneers in shoemaking as a business. We presume that it was the Hunts themselves who made the Hunt claim, and if one turns to the genealogical section in

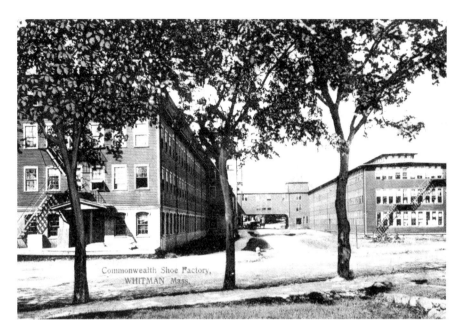

The Commonwealth Shoe Factory in Whitman was known for its "Bostonian"-style shoes. *Courtesy of the Historical Society of Old Abington.*

the same Hobart book, it will be seen that the Payns make the Payn claim and indeed, the Hunts admit that Payns went with Thomas Hunt to learn the technique. The Payns lived in that part of South Weymouth, near the boundary line, which became Abington territory when the colony line was corrected in 1847.

Stephen Payn secured a patent in 1806 on a machine for skiving (splitting) leather, and Zebulon Payn is said to have started making a supply of sale-shoes, but it is generally conceded that the Hunts had an advantage on the Payns in the general business of shoemaking, possibly because of the sheer weight of seven brothers simultaneously in the business.

#80: "THE BEGINNING OF THE SHOEMAKING INDUSTRY," JULY 19, 1967

Captain Thomas Hunt's brothers learned the trade of making "sale-shoes" from him in the 1750s, according to Benjamin Hobart's recording of the story. These brothers were Noah, David, Elias, Silas, Reuben and Warren.

Mr. Hobart is careful to describe the work that they took up as the making of "sale-shoes." In other words, they were shoes to be carried in stock for

sale by shoe stores, rather than custom-made shoes created on the spot for the various members of a family by itinerant workmen.

This was the tiny nugget of an idea around which shoemaking could become an industry—that trained artisans could work in permanent surroundings, under more efficient conditions, to make up various sizes of shoes to be held in stock in shoe stores.

All was still handwork, of course, from cutting the parts of the leather to shaping the curved toes and upper parts by pounding the wet leather into the concave shapes in the "lap-stone," and laboriously assembling the whole by hand sewing.

Captain David Hunt and Colonel David Gloyd of North Abington brought the workmen together in a "factory" (then called a "manufactory") as we read in the Benjamin Hobart story, and gave each man a specific step to accomplish, thus making for more expeditious work. A cutter, for example, only cut the parts, following around the edges of the patterns. Incidentally, makers of fine shoes still employ hand cutters. This allows the parts of a shoe to be arranged on matching parts of the hide, and also allows for the expert fitting of the patterns so as to eliminate unnecessary waste. A shoe company executive once made the statement that the cutters can make or break a company.

About the same time, Elias Hunt teamed up with Caleb Loud of East Abington to open a similar factory on North Union Street. The factory only functioned for a few years between 1820 and 1826, but if it predated the Gloyd-Hunt factory on Adams Street near the Schumatuscacant River in North Abington, then it was the first shoe factory in the original town. This part of former Union Street has been taken over by the Naval Air Station for extension of the runways.

The practice of bringing the workmen together in one building, of course, created a company, and the company demanded that the workmen receive wages on shares in the business. This was very early—when any link in the fiscal chain could easily fail to function—and the shoemaking pioneers experienced financial difficulties almost immediately. Hunt and Loud sold out to Abner Curtis, the colorful bachelor and financier of North Union Street, and they moved westward, first to Plainfield and then to Hamilton, New York, in 1826.

For a number of years then, the various parts of shoemaking were accomplished in small family shops scattered throughout the old town, and no one firm undertook to pay all the various workers. The emphasis began to be placed on selling the finished product, and salesmen were sent to open outlets in the Carolinas and New Orleans. The Southern shops flourished until closed by the Civil War.

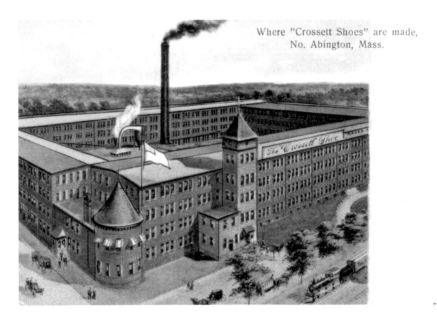

Where "Crossett Shoes" are made,
No. Abington, Mass.

Crossett shoes "make life's walk easy," or so said an ad in the early 1900s. *Courtesy of Kate Kelly.*

Before moving on from the shoemaking Hunt boys, one anecdote is worth mentioning. Reuben Hunt Jr., son of Reuben the shoemaker, was a Union soldier stationed in Washington when Abraham Lincoln was assassinated. He was so anxious to see the president's body lying in state that he forged a pass and successfully pulled off this escapade.

An Irishman
Comes to Town

#145: "Irish Immigrant Maguire,"
June 18, 1969

The house now numbered 197 Union Street was built in the 1860s by Owen Maguire, who was born in Ireland. It was built about the same time that young Maguire married Miss Nancy O'Neil, also an immigrant from the "Ould Sod."

Owen Maguire was born in Ireland in June 1841, the son of Peter and Catherine Leonard Maguire. This young man undoubtedly came over during the great migration from Ireland following the potato famine of 1846 and '47.

The potato blight actually originated in the United States in 1845, but in this early day of poor agricultural controls, it soon spread to Europe and Britain. In 1846 and '47, it struck full force in Ireland where the potato was the main source of food supply. During the five-year period beginning with 1845, almost one million persons died in Ireland—many of the casualties were the aged and the very young, who literally starved to death.

Beginning with 1846, a million and a half persons departed from Ireland within a period of ten years. Most came to the United States, landing at New England's coastal ports. These people were almost altogether destitute, friendless and jobless. One wonders how they found money for passage.

By a coincidence, the Old Colony Railroad was beginning to build a line between Boston and Plymouth just at this time. They needed laborers to clear the right of way, lay the crushed stone roadbed and wrestle the heavy rails into place and spike them down. And the young Irishmen needed immediate jobs and were willing to undertake any kind of labor. In short, they temporarily became "gandy dancers" as they referred to themselves. The railroad passing through Old Abington is credited with bringing the Irish in droves to these parts.

The construction of the train lines running through Old Abington coincided with the Irish potato famine. Hence, Irishmen appeared in the town as laborers in large numbers for the first time during this time period. *Courtesy of Carole Mooney.*

By the time of the 1850 census, the railroad was completed and there were 275 adults still living in Old Abington who listed themselves as "born in Ireland." They came here, found permanent work for themselves and stayed. The entire population of the old town (then including what is now Abington, Rockland and half of Whitman) was about 5,300. A solid 275 newcomers were a sizable number of foreigners to be absorbed in such a community within a period of three or four years.

Although the only male Maguire in this locality on the 1850 census was William, who was "living in" with David Torrey Jr., by 1855 we see the following Maguires paying tax in old East Abington: Daniel, James, James II, John, Patrick and William (by then living in his own house at what was later to be numbered 43 Bigelow Avenue).

Owen Maguire was still too young to be included on a tax list in 1855, but by the 1860s he had built a home for himself and established a fruit business. "He built up quite a large business and took his sons in with him," wrote Mr. Frank S. Alger in the Diamond Anniversary edition of the *Rockland Standard* on September 12, 1929.

Owen and Nancy had a number of children during the years. Perhaps the best remembered are Terrence E. "Ted" Maguire and his young brother Fred, who continued their father's business.

An Irishman Comes to Town

Ted was an up-and-coming young man. It is almost unbelievable, but it seems that in 1883, when he was only eighteen years old, he undertook to erect a business building on the corner lot next to the family homes. "Terrence E. Maguire's new fruit store on Union, corner of Water Street, is nearly completed, and will be opened today for the first time," read the *Rockland Standard* of August 18, 1883. "Mr. Maguire will keep his new establishment stocked with a fine assortment of fruit, confectionary and cigars." Although his father paid the taxes on this property, it is significant that Editor Smith attributed the building of the store to Ted.

Ted Maguire was a familiar figure at the annual Marshfield and Brockton fairs. In fact, it was the latter that almost proved his undoing in 1915. Ted, who was dozing on his wagon on the way home from the Brockton Fair late at night in September of that year, tangled with the dummy engine of the Hanover Branch, which was deadheading back to the mainline in North Abington.

One of Ted's daughters, the late Miss Blanche G. Maguire, was a well-known music teacher in this area. If she was indicative of inherited talent, then this must have been a musical family.

The Hill and the Crossroads

Beginning at the corner of Exchange Street we enter the business section of "the Hill." This is the quarter-mile strip of Union Street, which began late in the history of the town but soon concentrated most of the commercial as well as the civic activities of old East Abington.

In order to adequately tell the story of this interesting street, we shall have to remember houses and commercial "blocks" that are now gone, as well as those with the remnants still remaining. And we are going to see much moving of buildings and losses by fire.

The hill was a rocky, brambly expanse in 1813, with no more clearing than was necessary for some back pasturage.

But soon after the church was built and a roadway was cleared to become Union Street, three sons and one son-in-law of Captain Thomas Reed of 144 Market Street chose to build their houses near the church. Then a newcomer named Bigelow arrived in town to try his luck as a shoe manufacturer, shortly followed by several young fellows from the outlying parts of town who concentrated in this district to make shoes, too: David Cushing from East Water Street, Josiah Holbrook from Hatherly, the Pooles of Liberty Street, Stephen Payn from the town line at South Weymouth and Ira Stetson from Market Street.

Goddard Reed opened a store within a very few years, and this was the beginning of "the Hill." Work and worship created East Abington.

In telling the story of "the Hill" we could either develop it chronologically, jumping around geographically, or take it house by house and jump around in dates. We choose to move along the street geographically, and perhaps we shall conclude this section with a recapitulation that will trace the chronological development.

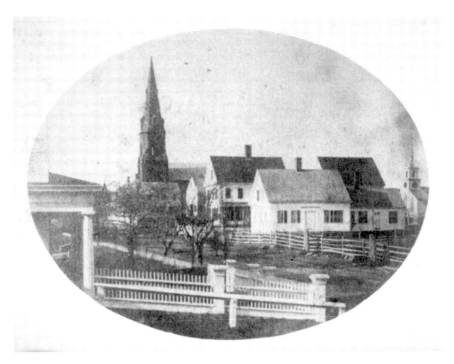

Religion towered over all during the early days of the East Abington settlement, as this view up Union Street in the 1860s suggests. *Courtesy of the Historical Society of Old Abington.*

379 Union Street

The Amos Phelps house, built in the 1880s, later became the home of the American Legion.

371 Union Street

The Micah H. Poole house once stood about where the Rockland Grill, Atlas Hardware and the laundromat were later located in the Baker-Selznick Block opposite the public library. The Micah H. Poole house was moved to 92 Stanton Street when the present business block was built in the 1930s. The late George W. Torrey, who was a grandson of Micah Holbrook Poole, wrote that his grandfather went to California in the gold rush of 1849. He went with his two brothers, Franklin and Cyrus. They traveled by ship and by land, crossing at the isthmus in Panama, and they stayed about a year. Micah H. noted in his journal that he dug and panned both "by the river" and "in the canyon." He came home some five thousand dollars richer and began manufacturing shoes soon after his return. George Torrey wrote that his grandfather was an ardent abolitionist and, he suspected, maintained a station on the "underground railway," possibly in this house, which was built in 1830. Miss Ruth Torrey

owns her Uncle George's manuscript, and a copy is on file in the archives of the Historical Society of Old Abington. Micah H. Poole was appointed postmaster of the East Abington office in 1847. He died in 1882 at the age of seventy-four.

365 Union Street

The Micah H. Poole shoe shop was located on the south side of his residence. In the 1855 evaluation it was called a "store" and was evaluated at $850. Benjamin Hobart says that the 1860 Federal Census quotes Micah H. Poole as making $24,347 worth of Scotch and congress boots and Oxford ties in that year. By 1875, the building was called a manufacturing shop and was evaluated at $750. By 1881, however, the bird's-eye view of Rockland showed a large complex of buildings here, occupied by Arnold and Weatherbee, shoe manufacturers.

It was in the little shop that the *Rockland Standard* was published. It was born across the street, according to Mr. Frank Alger's recollections in 1939, and was published for awhile on the second floor of the Union Company before moving to the Micah H. Poole shop. Its first issue was dated July 26, 1884. Edward C. Osborne, who was a musician as well as a journalist, and William J. Barry founded it, but this newspaper is best remembered as the voice of Miss Hulda B. Loud, who first edited, wrote for and later purchased the paper in 1889, after which she wrote its editorials and handled its policies for many years. An ad in the 1909 *Directory of Rockland* shows one of the poses of Miss Loud in her famous polka dot dress with a scarf knotted at her neck, and states that the *Independent*, published every Friday, had new type and the latest presses, and was located at 365 Union. The *Independent* was finally absorbed into the *Rockland Standard* in the 1930s.

361 Union Street

The Josiah Soule house, so-called, which is thought to have started as the Ira Stetson house, was built in 1830. No house is shown here on the map dated January 1, 1830, but the federal census taker found Stetson here later in the year, which leads us to believe that his house was erected during that summer. Cyrus Nash mentions that Ira Stetson, son of Oliver of Market Street, seems to have removed from town shortly after 1832, and by the time of the 1848 map we find Josiah Soule of Duxbury here.

Josiah Soule was listed as a shoemaker, age forty-nine, in the 1850 census, and in the 1855 evaluation his "shop" and barn together were worth four hundred dollars. Josiah Soule Jr. increased activities here and did twenty thousand dollars worth of business in 1860. Mr. John A. Rice purchased the old house for his residence in the 1880s.

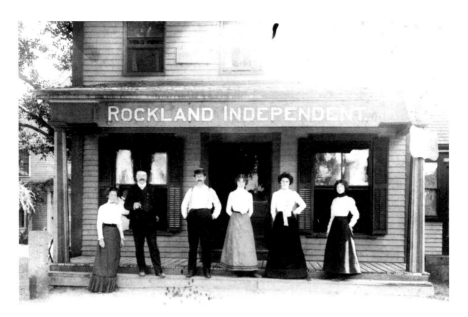

The name of the *Rockland Independent* newspaper caught the essence of the community's spirit in the later years of the nineteenth century. *Courtesy of the Dyer Memorial Library.*

Mr. John A. Rice was born in Vermont and first came to Abington about 1854, when he clerked in the Nahum Moore dry goods store in the old Phoenix building on the northeast corner of Union and Park, where Peterson's and Morse's are now located.

The Rice residence was damaged by fire on September 10, 1893, when the Jackson Hotel on the north corner of Webster Street burned in a disastrous conflagration that destroyed several houses and damaged much property on both sides of Union Street. The Rice house was extensively rebuilt and can still be seen today behind the storefronts, but whether any of the Ira Stetson house remains, we are not able to say. Certainly what can be seen today has none of the appearance of any house that can be detected in this vicinity on the 1881 bird's-eye view.

#146: "Union Square Area," July 2, 1969

As we approach Union Square, we come to a short block on the west side bounded by Linden Street and the square itself.

Back in the days when this locality was marked by a very important intersection—the Old Colony Railroad and the highway, and later the

electric streetcar line—this block was longer and there were two buildings here that housed a number of activities.

The 1874 map shows Joseph and Joseph E. French's grocery store on the corner of Linden Street. Later, this became Clarence W. Burgess's hardware, stove and kitchenware emporium. His ad in Foss's 1909 *Directory* publicized the fact that he also sold Monarch mixed paint (100 percent pure) and took orders for plumbing and heating.

In addition, Mr. Burgess with Mr. Roderick MacKenzie, the blacksmith, ran an ice business from this busy headquarters, and Jenkins & Simmons Transfer Company, who then did their hauling with horse and wagon, functioned from here during this period.

In the building to the south, James W. Young had a store and "saloon." Probably the latter was a short-order eating counter in connection with his grocery, although we do catch references now and then to its being raided during the periods when the town voted "dry." And it must be admitted that a cryptic remark in the *Standard* once described Union Square as "Rum Square."

We get an interesting comment, in 1900, that Young's building was moved nearer the sidewalk in order to line it up with Burgess's next door. Actually, Union Square is not very old. Union Street itself was not put through until 1813, and Water Street was not extended westward from Liberty Street until 1854.

In the town report of Old Abington of that year we read that the county commissioners ordered the laying out of "about 500 rods from the west end of Water Street, thence to near Arioch Thompson's on Central Street—to be completed on or before the first day of December, 1855."

In other words: from the intersection of Liberty and East Water Streets westward across Union Street to the junction with Central Street near the Abington line. Arioch Thompson lived in the house in the fork of West Water and Central Street.

Thus was Union Square formed, only a few years before the beginning of the Civil War. It was widened to its present proportions in 1898. There is nothing about this square to commemorate the Civil War, however a war memorial monument to the Rockland boys who made the supreme sacrifice in the Spanish-American War of 1898 and World Wars I and II was erected there and dedicated in 1949.

The Hanover Branch was built in 1867 and began service in 1868. It crossed Union Street at Union Square, and for years there were gates protecting the crossing. Gatekeepers manned these barricades, lowering them while the train passed, and raising them when it was safe for traffic to resume. The railroad train, of course, received precedence.

The Hill and the Crossroads

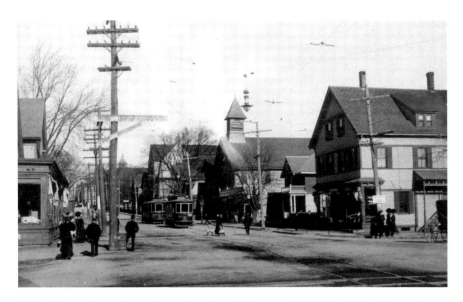

Union Square, located on a plateau just beneath the top of the hill on Union Street, has been a busy place throughout the years. *Courtesy of the Historical Society of Old Abington.*

The first railroad station was a shed-like affair with a platform running parallel with the tracks and located on the southeast corner of the intersection, next to the tracks and street. It was in this little building that the Rockland Savings Bank had its beginning with Zenas Jenkins, the first treasurer, who was also ticket agent for the Hanover Branch.

The "new" railroad station, built farther back from Union Street, is now abandoned by the line, and was occupied by Jim's Liquor Store and now Dunkin' Donuts.

Having arrived at Union Square, we have come to the end of the Hill's business district. From here, southward, we shall revert to the procedure of mentioning only the houses that were shown on the 1830 map, or houses about which we have some interesting comment.

However, we must mention three other business enterprises before we leave this locality. One is the Albert Culver Company, which still flourishes. The second is the big factory of the Rockland Company, which once stood here and was an early cooperative venture in shoemaking, and the last is the rooming house now known as the Hotel Thomas.

Albert Culver, who was born in Poultney, Vermont, came to old East Abington and was a bookkeeper for Jenkins Lane & Son's shoe factory. In 1862, he married Miss Nancy S. Howland of East Abington.

He caught the eye of Mr. E.Y. Perry, and when Mr. Perry became interested in establishing business enterprises along the Hanover Branch

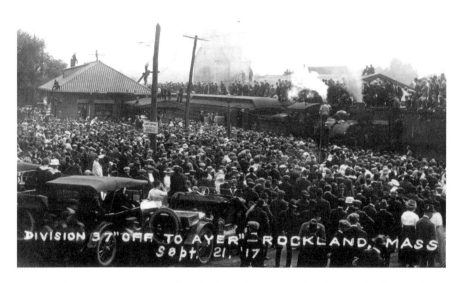

DIVISION 37 "OFF TO AYER" — ROCKLAND, MASS Sept. 21, '17

With a train station as its heart and soul, Union Square has played many significant roles in Rockland history, including acting as the send-off point for local soldiers headed to fight in World War I. *Courtesy of the Rockland Selectmen.*

Railroad for the mutual advantage of both shipper and conveyor, he backed young Culver in the establishment of a hay, grain and coal company.

The late James W. Spence became treasurer of the Culver Company, and his son, Robert J. Spence, now manages the company, which today specializes in fuel oil.

The 1879 map of Rockland shows a large factory building between the old railroad station and the building now known as the Hotel Thomas. Five years previous to this it does not show on the 1874 map, so we can assume that it was built during the interim.

Mr. William H. Bates was the manager of the shoe factory. The company continued manufacturing until the 1890s. After some trouble, Mr. Bates attempted to reorganize it and moved the company to Church Street, but it was not successful.

The building now known as the Hotel Thomas was built in 1893. In the *Rockland Standard* of March 24 of that year we read:

> *Mr. B.F. Richardson is moving from his quarters on Vernon Street to the fine new building for his boarding house business on Union Street near the depot, where he will continue his business on a larger scale.*

Once a Landmark

#111: "THE PHOENIX BLOCK," JULY 31, 1968

The northeast corner of what is now Park Street at Union is an important historical spot in old East Abington. This was the site of the old Phoenix Block, where Rockland's first town meeting was held in the third-floor hall on March 19, 1874.

A picture of the old block was published in the *Yesteryears* booklet of 1962 on page forty-eight, but this building burned in 1929, at which time it was replaced by the present Phoenix building.

It seems that the old Phoenix building was rightly named for it was always rising from its own ashes, like the famous bird of ancient Greek literature, but the present building is a fireproof one of brick and stone. In 1968 it was occupied on the ground floor by Morse's dry goods, a TV stamp redemption store in Cote's old quarters and Peterson's news store. The upstairs offices were occupied by a dentist, a chiropractor and an advertising and art studio.

The old Phoenix Block was preceded, however, by another wooden business block known as the Manson building, which also burned.

The Manson building was built about 1852 by Rufus T. Estes who, it will be remembered, was one in the chain of owners of the dry goods business established by Robert Estes, "the peddler." Estes sold the building to Ellis & Moore who, in turn, sold it to Captain John Manson. Apparently it was from the last named that it came to be called the Manson building.

It was in this store building that Mr. John A. Rice began his career, clerking for Nahum Moore. This was about 1854. Mr. Rice was taken in as a partner in 1855 and Moore & Rice shows here on the 1857 map, long before Park Street was cut through.

In time this old building became the property of A.S. Reed & Co. If there is a picture of it in existence we have never seen it, but it was probably built in the style of the day, with a front porch. It was big enough, however, to have an auditorium

of sorts in the upper stories. Joseph Gardner is credited with suggesting the name of Manamooskeagin Hall, by which this room was known. It was in this hall that the Rockland Baptist Church Society was organized in March 1854.

The Manson building burned on January 21, 1868, and Mr. Reed promptly began erecting the first Phoenix building.

This was a period when a pyromaniac was flourishing in East Abington village, and whoever he was, he couldn't contain himself at the sight of all that beautiful dry timber going up, so he carefully arranged a pile of shavings and set fire to the unfinished building on September 7, 1869. Luckily the blaze was discovered immediately and was extinguished with water from the town's new cistern at the head of Webster Street.

There's one good thing to be said for the firebug—his activities in these years frightened the townspeople to the extent that they voted money to build the six underground cisterns at strategic spots in the business district, and they purchased the King Philip fire engine, which in 1969 was owned by Ralph Tedeschi and still functioned at musters.

The old Phoenix also caught fire in 1904, and burned again to some extent in 1914, at which latter time it was rebuilt without the famous Victorian cupola over the front entrance.

Rice's dry goods store continued at the old site and occupied part of the ground floor when the new "Old Phoenix" was put up in 1869. When Mr. J.A. Rice's brother, Colonel C.L. Rice, came back from the Civil War, the partnership of J.A. & C.L. Rice was formed and occupied the north side of the ground floor, as well as the rooms above on the second floor. The picture that was published in *Yesteryears* plainly shows the Rice's dry goods and furniture signs with Estes & Whiting, who sold ready-made clothing, occupying the south half of the ground floor.

Later, L.W. Orcutt bought out the men's clothing business and ran it here for many years. An entrance to his store was cut into the corner of the building and the door opened on the diagonal.

There must be many Rocklanders who remember the sounds and smells of these old emporiums with their bare wooden floors, their heavy display tables laden with merchandise and, above all, their air of leisurely and pleasant business transactions.

Mr. Abraham Lelyveld remembered Orcutt's being run later by a Mr. Snow, and the gradual deterioration of this period piece of men's and boys' "ready-to-wear."

After J.A. Rice moved across the street to his new brick store building in 1883, a similar store called the Rockland Dry Goods Co. was opened in the old Phoenix building and continued in business until 1903, when the owner, a Mr. Clark, removed to Concord, New Hampshire.

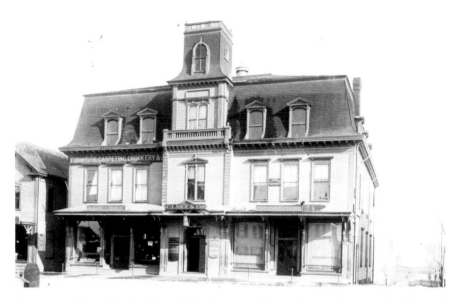

Signature buildings like the Phoenix Block are mostly lost to history. *Courtesy of the Historical Society of Old Abington.*

The YMCA also occupied rooms in the old Phoenix for a few years.

The auditorium on the third floor was the largest in town for twenty years, and figured in every exciting meeting that was held from about 1870 to 1891, when it was superseded by the Opera House in the Savings Bank building.

Probably no other event ever exceeded the importance of Rockland's first town meeting in 1874. The night of March 19 was cold with a miserable downpour of snow, rain and sleet. The weather, however, did not dampen the spirits of the men of the town who turned out in full force to elect officers and begin the business of the town.

As might be expected, Ezekiel R. Studley, "father of Rockland," was elected town clerk. In addition, he was entrusted with the offices of treasurer, tax collector, selectman, tax assessor and overseer of the poor. He was subsequently chosen chairman of the board of selectmen, who also functioned, in those days, as tax assessors and overseers of the poor. Mr. Studley's diary, from which Rose White copied the excerpts that appeared in the *Yesteryears* booklet is now owned by Mr. and Mrs. David Studley of Pleasant Street, West Hanover.

Eventually the old auditorium degenerated and mostly sat empty and collected dirt, although a skating rink was opened in it in 1898. It was apparently utilitarian rather than decorative, and the acoustics in the big hollow room with its bare floors and bare walls and ceilings, broken only by the balcony and scanty stage facilities, must not have been the best. When the much more elegant Opera House was opened, audiences realized how primitive their earlier hall had been.

A Very Busy Corner

#134: "THE SAVINGS BANK SITE," FEBRUARY 12, 1969

Another one of Rockland's many buildings that was moved once stood about where the Rockland Savings Bank's main room is now located. It started as a little neighborhood store building on Spring Street, diagonally across from the ancient Deacon Nathan Stoddard residence. That would make it a little south of where the Meadows Home for Aged Men stood in 1969.

In the late 1830s, Richmond Stoddard, son of Deacon Nathan, decided to get off the farm and go into business on the Hill, in the center of town. He brought his house with him. He moved the store building and set it down on Union Street near the Congregational Church. This would one day be the south corner of Church Street, but it was a full generation before that street would be cut through between this house and the church. Emery Jenkins told about his parents trading at the store while it was still on Spring Street, and his recollection got recorded in a little notebook that is now in the Dyer building, Abington.

At the new location, a porch was added and a yard built, and no suggestion of a store building was visible any longer. In the 1850 federal census, this estate was evaluated at $2,700, and Richmond Stoddard, age forty, was called a "stable keeper."

Around 1855, however, Mr. Stoddard sold this house to James Underwood about whom we wrote in the forty-seventh "Research Reporter" column of September 7, 1966. Church Street was built in 1867 while Dr. Underwood was living there. About four years later, in 1871, Dr. Underwood died suddenly of a heart attack.

In 1874, George Wheeler, erstwhile innkeeper, became the keeper of the lockup and he took over the Stoddard-Underwood house. This was quite

handy since the lockup stood over on the other side of Church Street, back near the south entrance of the town's present-day parking lot. The remains of the foundation can still be seen there.

Somebody along the line added a gazebo or summerhouse in the backyard of the Wheeler place. It was hexagonal and shows in a picture after the 1890 fire. The residence was destroyed in this disastrous "Brown Church Fire" of July 16, 1890, but the gazebo was saved. It is interesting to note that a similar hexagonal gazebo is to be seen in the yard of the Estes house, in a picture that may be of a slightly later date. One wonders if it might be the same gazebo. Or did a good gazebo salesman come through town?

The *Foss Directory of Rockland and Hanover, 1892*, included a short history of Rockland, undoubtedly written by Town Clerk Ezekiel R. Studley, and Mr. Studley furnished a picture of the Brown Church burning, which the publishers included in the volume. In Mr. Studley's handwriting, under the picture, we read: "House of Geo. Wheeler—Right." A corner of the porch and the paling fence at the street are all that show of the house. The same picture, from one of Mr. Estes's negatives, was reproduced in the *Yesteryears* booklet on page fifty-three.

The three-story wooden Underwood building was erected in 1868–69. It was of Mansard architecture with the third-floor windows appearing as semidormers in a hip-like roof. A picture of it was included in the *Yesteryears* booklet on page sixty-four.

The building housed the town offices and the public library; Hartsuff Post, GAR; and one of Chute's grocery stores at the time of the 1890 fire. Many hands joined in saving the contents of the offices. The library books were taken farther up the hill to Mr. Gideon Studley's barn for temporary storage, and the town offices took up quarters in the Payson building, which stood where the Rockland Federal Credit Union is now located on the corner of School Street. Chute's grocery, which was the "southern branch" of the main store at Poole's corner at North Avenue, had been started here by Mr. Henry J. Cushing. The store space on the ground floor, south side, of the Underwood building had previously been occupied by Wilbur & Gray until 1883, when Mr. Chute moved in.

The result of the leveling of this section of the Hill was that the big brick savings bank was erected in 1891. After it was completed, Chute reopened his branch grocery in one of the storefronts there.

The Hartsuff Post put up a building of their own, which still stands at 34 School Street.

The only local building that was perhaps more impressive than the Abington Savings Bank was the Rockland Savings Bank. *Courtesy of the Historical Society of Old Abington.*

#135: "ROCKLAND SAVINGS BANK BUILDING," MARCH 5, 1969

The big, brick Rockland Savings Bank building was the town's largest and handsomest building in its day. It occupied a space of five full storefronts on Union Street, and four around the corner on Church Street. In fact, it still does that, but it once rose to three and a half stories in the air, and it originally sported a diagonal tower with Victorian bonnet over the entrance to the banking quarters at the corner.

The First National Bank of Rockland (now the Rockland Trust Company) was then located cheek by jowl with the savings bank, in a sort of bundling arrangement. State law required that the two services be separately maintained, and the banks conformed by having separate entrances. The National Bank used the Union Street entrance, while the savings bank's address was 5 Church Street.

The storefronts on the ground floor on Union Street were rented out. At first, they were occupied by Jacobs Brothers, who had a variety store, J.P. Morey's clothing store, Daniel O'Brien's drugstore and Fred Lantz's hardware store. Hedge and Hall soon bought out Lantz in 1889, and after two years this firm became Hall and Torrey, when Harry S. Torrey bought Mr. Hedge's interest.

The upstairs office spaces were occupied at first by the town offices, the Howland Insurance Co. and Tilda Mangan, a dressmaker. The Amos Phelps Insurance Agency opened upstairs in 1896, but most of the third floor of the bank building was occupied by the Union Glee Club.

A Very Busy Corner

The Opera House, of course, occupied most of the second floor and had its own entrance by way of Church Street. Despite its elegant name, its uses were varied.

Town meetings, which had previously been held in the new "old Phoenix" auditorium, were transferred to the Opera House, which could accommodate an audience of a thousand. Mr. Edwin Mulready was the first moderator of a town meeting in the new quarters, a service for which he was paid ten dollars.

High school graduation exercises were held here for about fifty years and young Rocklanders marched solemnly across its stage to receive their diplomas for two generations.

All kinds of important special events also occurred in this auditorium, such as the famous Easter reunion of the Holy Family parish on April 13, 1903, when the former Miss Angelina Poole house was raffled off. This big residence had been moved from 403 Union to 46 Exchange Street to make way for the building of the rectory. "Little Miss Clara Tobin" of Linden Street drew the lucky ticket and the house went to Postmaster John H. Flavell, who is said to have gotten the place for twenty-five cents.

The list of entertainments, both amateur and professional, that were produced in the Opera House for the approval of the local citizenry is almost endless. The management of the Opera House was by way of contract. L. Drayton Bates managed it until 1903, when he was succeeded by John J. Bowler who had previously been functioning as treasurer. Mr. Bowler continued until the 1920s, varying his programs with silent movies as they became available. When the Strand Theatre was opened in the old SATAS (Saint Alphonsus Total Abstinence Society) building, it installed facilities for talking pictures and superseded the Opera House as a moving picture theatre.

Social dancing was another feature of the Opera House, ranging from the big, all-time social event of the Glee Club's twenty-fifth-anniversary ball on January 1, 1903, to regular Friday night hops accompanied by local orchestras.

There were many amateur performances put on by local clubs and groups around town. These included such diversity of entertainment as debates, plays, operettas, minstrel shows and athletic events. The professional shows ranged from almost bankrupt stock companies to the finest performances by nationally known actors, actresses and musicians. All were highly popular in the pre-radio, pre-television days.

But the entire installation, of course, was owned by the savings bank.

The Rockland Savings Bank was founded in 1868, with its first office in the railroad stations at Union Square because that was where Zenas Jenkins, the first treasurer, was ticket agent. The banking business occupied only part of his time because deposits could only be made on Saturday afternoons and withdrawals were honored only quarterly—and then upon two weeks' notice!

The savings bank office moved around, in the early years, according to who was currently the treasurer. In 1869, when W.B. Studley took on that responsibility, the office moved northward on Union Street to his jewelry store where Western Auto was located in 1969 on the south corner of School Street. In 1876, Town Clerk Ezekiel R. Studley became the treasurer. In 1885, the bank's office was moved to the Webster building and pictures of the period show the bank's name in gold on the front window of the second floor. Town and bank were thus temporarily separated, with the town offices having quarters in the Underwood building. Mr. Studley found his two jobs in relatively convenient proximity again, however, after the 1890 fire and the erecting of the savings bank building when the town offices moved into the new building.

The post office also occupied quarters in the big brick building for a number of years.

The cornerstone of the savings bank was laid on September 10, 1892. It was a sealed box with enclosures pertinent to the period. These included contemporary town and water department reports, an 1888 business directory, histories of the local churches and pictures of schools, newspaper of the day, plans of the building itself and records of the fire (which had cleared the space for its erection), maps (including the 1881 bird's-eye view of Rockland) and a set of silver coins and stamps issued in 1891.

After the Opera House and Union Glee Club quarters were no longer in active use, parts of the upper stories were "dead wood" in the words of President E. Wayne Harlow, so the savings bank finally decided to have them removed. The decision was made in 1964 and the work actually began in September 1965.

Wreckers carefully took off the roof and the upper stories and were starting to work on the last brick wall standing on the south end when a gale wind blew up. Despite props and shoring up, it began waving in the gusts. It produced ominous creaks and groans and luckily gave warning of trouble to come. Customers and employees vacated the bank and stores in the vicinity before the walls came tumbling down onto the Grant building next door. Nobody was hurt, but what had been Sears, Grant's and the Costello Sports shop was left a shambles. Rain soon turned the cellar into a pond reflecting the sky.

The savings bank building stood in 1969, one storied and flat topped, with its Union Street rental space occupied by Brockton Edison, Carrol Cut Rate Cosmetics and Lloyd's Variety Store.

At first it seemed shocking to see so much sky where the brick walls once rose to cut off the light, but time marches on, changes do occur and people manage to accommodate themselves to them.

Entrepreneurs,
Civic Leaders, Brothers

#101: "MR. JOHN A. RICE,"
MARCH 20, 1968

John Alphonse Rice was born in Northfield, Vermont, on January 29, 1830. His father was Alphonse Rice and his mother was born Mary Cardell.

The biographical collections published by Beers in 1912 have this to say about Mr. Rice:

> *He was reared on a farm and, not unlike farmers' sons in general, worked on the farm in season and attended the neighborhood school in winters. At seventeen years of age he began teaching school himself, an example which was subsequently followed by his younger brothers and sisters. This vocation he followed for four winters in his native state and later at Avon and Randolph, in Massachusetts, two winters.*
>
> *When twenty-one he went west, and there for several years was variously occupied. Returning to the east, he was for a time in the employ of his brother-in-law, Elijah Blanchard, being postmaster of the place, and as well carrying on a general country store.*
>
> *His next experience, which proved the real starting point to his successful career, was as an assistant to the proprietor, Nahum Moore, of a dry goods and furniture business in the town of East Abington, now Rockland, Mass. Mr. Moore was then a busy man, legislator, etc., and needed someone upon whom he could depend, and it was soon proved that he had found the man in the person of young Rice, in whom he was quick to see the qualities required.*

This was about 1854.

The beginning of this store can be traced back to young Robert Estes, "the peddler," who set up shop here as early as 1842.

There was much taking in of new partners, selling out and changing ownership in the early days, but the thread of the business itself can be traced, unbroken right down through the years. It runs something like this (years being approximate):

1842—Robert Estes (with Samuel Ellis as clerk)
1843—Samuel Ellis (with Rufus T. Estes, brother of Robert, as clerk)
1845—Ellis & Estes (until Ellis sold out to Leonard P. Brown)
1850—Estes & Brown
1854—Nahum Moore (with J.A. Rice as clerk)
1855—Moore & Rice (until Moore sold out to a Mr. Eldredge of Boston)
1857—Rice & Eldredge
1859—Rice sold out to Eldredge

Apparently Mr. Eldredge was an absentee owner, and his given name has not come down to us. It would be interesting to learn who conducted the business for him during these few years, but that is another fragment of information that has not come to light.

At this point, Mr. John A. Rice took a stock of wares on the road and went west to St. Joseph, Missouri, the kickoff point for wagon trains heading west. It was a profitable move, and he came back to New England, first to Vermont and then back to East Abington Village by 1865, at which time he bought back the old company once more and became sole owner of the business.

During these years, the store had occupied quarters at the Rocrest corner (now Belmont Street), the Thomas Reed IV building where the parking lot now is opposite the head of Webster Street and the old Manson building, which preceded the first Phoenix building on the northeast corner of Union and Webster Streets.

Mr. Rice was located in the Manson building when his brother, Colonel Charles Rice, came to town following the Civil War, and the two entered into partnership.

The J.A. & C.L. Rice Company suffered damages when the Manson building burned on January 21, 1868, but immediately carried on in temporary quarters until the first Phoenix building was erected on the site in 1869. Here they occupied the northern half of the ground floor, as well as the second floor.

In 1872, Colonel C.L. Rice took over the furniture department as a separate business, and from this sprang the C.L. Rice & Sons Funeral Home, as we shall see. This is possibly the oldest continuous business in Rockland.

Although he ranged far and wide to follow his dreams, John A. Rice always returned to East Abington/Rockland as his home. *Courtesy of the First Congregational Church of Rockland.*

Mr. John A. Rice married in 1857 Miss Sarah S. Soule, daughter of Josiah Soule. It was her family home that later became the Deacon John A. Rice residence at 361 Union Street.

Five sons were born to them, but only one grew to adulthood. He was John Wesley Rice, born in 1868. He was a brilliant and talented man who received degrees from both Yale and Harvard, with a PhD from the latter institution in 1898. He was a professor of Greek and also biblical literature, and taught in both Vanderbilt University in Nashville, Tennessee (your

Research Reporter's natal town), and Ohio Wesleyan. He was also talented musically and could be called upon to play the organ for church services when needed.

After his father's physical condition required that he return home, Professor Rice maintained educational affiliation on an advisory basis with the library of Princeton University.

In the "Folks We Used to Know" column of the *Rockland Standard* of December 29, 1921, we read the following concerning Mr. John A. Rice:

> *Mr. Rice is remembered by his associates as a pioneer for shorter hours for his clerks, which finally culminated in the movement for closing the stores on Tuesday and Thursday evenings, and finally on every evening except Friday and Saturday.*
>
> *He was very charitable and lots of money and dry goods went from his store as a free gift to many worthy persons.*
>
> *Mr. Rice greatly enjoyed the office of senior deacon of the Congregational church for many years and performed his duties very acceptably and with great credit to himself and church. He was also one of the largest donors to the church for several decades.*

John Alphonse Rice died on September 18, 1913, at the age of eighty-three years, seven months and twenty days.

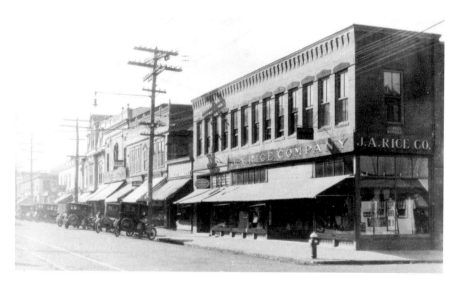

John A. Rice had many business partners during the early years, but eventually he made a go of it on his own. *Courtesy of the Historical Society of Old Abington.*

#114: "Col. Charles L. Rice,"
August 21, 1968

Colonel Charles L. Rice will undoubtedly go down in history as one of Rockland's all-time great civic leaders, if for no other reason than because of his activities in connection with the old Rockland Commercial Club.

He can be considered the father of the Commercial Club, and served as its first president. In 1909, Colonel Rice wrote a short history of the founding of this group of Rockland businessmen, and told briefly of some of the activities that played such a large part in the development of the town.

"I adopted Rockland as my home forty-three years ago," he wrote.

> At that time, in three-fourths of a mile of what is now the most thickly settled part of the town, there were houses and vacant lots, enclosed or separated from the street by the old-fashioned straight-rail fence.
>
> Ten years before the organization of this club I procured a copy of the by-laws of the Brockton Board of Trade and made an effort to interest our citizens in forming a similar organization in Rockland. Not being successful in creating the enthusiasm I had expected, the matter was dropped until a literary club, composed of Judge Kelley, J.S. Smith, J.B. Poole, C. Burleigh Collins, Lawrence Donovan, and others, was convinced that there was need of something besides literary work, and they invited half a dozen or more of us to meet with them at the Sherman House. After a banquet and a brief discussion of the matter, a temporary business organization was effected with myself as president, and the literary organization passed out of existence.
>
> It was urged that Commercial Club might be considered the more democratic name, and that all classes would be more likely to join than if it were called a "Board of Trade." We spent some days in soliciting members and then formed a permanent organization with between sixty and seventy charter members.
>
> In September 1884, at a special meeting, it was voted to raise $4,000 for building a factory and establishing the business of tack manufacturing, the money to be refunded at a specified time, which was done.
>
> Through the efforts of the club, $1,000 was contributed as an inducement for the Rubber Goring Company to purchase the old skating rink (on Park Street) and establish its business here.
>
> The movement to establish a national bank met with a ready response, individuals subscribing the amount of capital stock required.
>
> A movement for a fund for a soldiers memorial resulted in raising about $2,000 within a short time, for which much credit is due Judge Kelley.

The question may well be asked: Where would Rockland be today without men like Charles L. Rice? *Courtesy of the Dyer Memorial Library.*

In 1887, the amount of stock asked for to enable a company to establish a gas plant was subscribed, but a move to form an Electric Light Company in Abington and Rockland led to the giving up on the gas plant and the establishing of the present (e.g. 1909) electric light and power plant.

In 1889, $1,500 was raised by subscription to induce B.A. Burrell to transfer his shoe business to Rockland, which he did.

Discussing the matter of public buildings, the club expressed itself by vote, as the sense of the meeting, that the Rockland Savings Bank build a brick block, which was done in 1891.

In 1891, Rockland and Abington, after much discussion of electric road, decided upon nearly the present (e.g. 1909) system. Early in the following year, Judge Kelley assured us that an electric street railway would be a reality by fall. During the same year $20,500 was raised by subscription to build a plant for Chapman & Calley. The factory is now (in 1909) occupied by Rice & Hutchins, who have made several additions to the original building.

In July 1894, the club carried out plans for an extensive trades display.

After Miss Angela W. Collins got the promise of $12,000 from the Carnegie fund for a new library building, the question of combining the memorial funds was discussed, and it continued to be an interesting subject until the present building was decided upon.

In 1904, the subject of a new depot was again taken up and continued by a good working committee on transportation until we were provided with our present commodious quarters [later Jim's Liquor Store, then Dunkin' Donuts at 21 East Water Street].

We used our influence inducing the Fred Thompson Blacking Company to transfer its business from Boston to its present plant on Grove Street.

In 1905, the Emerson Shoe Company of Brockton was influenced to locate in Rockland. In this case President A.W. Donovan seemed to be a committee of one who managed the undertaking.

Through the influence of the club, a gas company has been organized to supply the towns of Rockland, Abington, Whitman and Weymouth.

The rather amazing record of the accomplishments of the Commercial Club demonstrate what "pulling together" can do when a group of civic-minded businessmen set themselves to promote their town.

In addition to his efforts in creating the Commercial Club, Colonel C.L. Rice was also active in organizing Hartsuff Post No. 74, Grand Army of the Republic, and served as its first commander.

Colonel Rice, who was born in Vermont but called East Abington his hometown, by choice, is one of the men we like to think of as the giants of early Rockland.

Conflagrations

#206: "Disastrous Fires Have Destroyed Property, Lives,"
October 29, 1970

In 1901, Mr. Lorenzo D. Perkins compiled a list of fire alarms and other information about the Rockland Fire Department for a souvenir booklet. In it he tells about "the first fire in town of which any information is available."

He says that in 1808 Stephen Long, a "highly respected Negro of giant stature," had been courting in Hanover and noticed a fire in Stetson's store on Market Street as he was heading back home. This was the "West Indian and dry goods store," which was on the west side of the Barnabas and Ephraim Stetson House at 620 Market Street. The house and store stood on what was the outside curve of the old road that, in 1970, circled around behind Staples service station before the newer and straighter link was put through in front of the garage.

As the story goes, Stephen climbed up on the ridge pole of the house and "when a falling ember ignited a shingle he would inch along to the nearest accessible point, and then with a well directed mouthful of saliva and tobacco juice smother the incipient blaze." This is said to be the way the Stetsons' house was saved, although their store with its West India goods, including both rum and molasses, was lost.

Mr. Perkins thus credits Stephen Long with being Rockland's first firefighting apparatus.

In the reconstruction of the records, Mr. Perkins lists twenty-one fires known to have occurred between 1831 and 1873: one each in 1831, 1836, 1838, 1844, 1852, 1855, 1859, 1860, 1862, 1863 and 1864; two each in 1867 and 1868; four in 1870; and one in 1873.

The more dramatic ones were:

1814—Reverend Samuel Colburn's house burned before it was completely finished. It occurred some time between June 3 of that year, when the frame

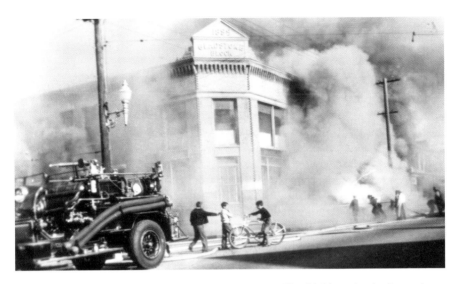

Fires, sadly, have long been a part of the Rockland story, like this blaze that broke out in the town offices in June 1941. *Courtesy of the Historical Society of Old Abington.*

was raised, and November 26, when Cyrus Nash wrote about it in his diary, presumably near the latter date.

The house was rebuilt, with a new frame raised on June 13 of the following year on the same spot—a spot now occupied by the Rockland Trust Company on the corner of Union and Taunton Streets. The wind apparently blew a gust down through the fireplace, setting fire to carpenter's shavings.

1844, Tuesday, March 5—the Thomas Reed IV House at the site of 332 Union Street (presently the parking lot opposite Webster Street) caught fire from a defective chimney. It was then occupied by Reverend Horace Dean Walker, who had just accepted a call to town, and his first concern was for his file of sermons.

1867, Sunday, September 8—Jairus Keene's house burned, his two young lady daughters perishing in the smoke. This house stood at the site of 251 Union Street, about where Holstein's Shore Store is now in the Blanchard Building. Mr. Keene moved out of town immediately after this tragedy. He died in New Orleans in November 1877, and it is said that he never fully recovered from the horror of this incident.

1868, Tuesday, January 21—The big Bigelow fire on the east side of Union Street where Park is now cut through. It was the magnitude of this fire, as much as anything else, that influenced the Old Town to purchase hooks and ladders

for the four geographical sections and thus paved the way for the eventual transfer of the firefighting to being a tax supported town department.

With the emphasis upon firefighting and the dramatic excitement surrounding conflagrations, it followed that the East Village soon developed a firebug.

John Lane's house on the north corner of Union and Pacific (Tuesday, September 1, 1868), the Phoenix Building then being built where Peterson's store is now located at 319 Union Street (six days later on September 7), the old grammar school building on the present corner of Church and Blanchard, where a town parking lot is now located (Saturday, January 15, 1870), and Leonard Blanchard's house and stable, which he had built on the Jairus Keene burned-out site (Sunday, April 17, 1870), followed each other in rapid succession. Abner Curtis's barn at 1007 Union Street was burned on Friday, October 10, 1873, with the loss of farm animals, implements and feed.

Then, on the night of the torchlight parade celebrating the incorporation of the new Town of Rockland, on Wednesday, March 11, A.W. Perry's shoe factory on Vernon Street caught fire. There was a great deal of confusion in trying to assemble firefighters and get the King Philip and the hook and ladder to the scene. The crew mistakenly went first to William G. Perry's

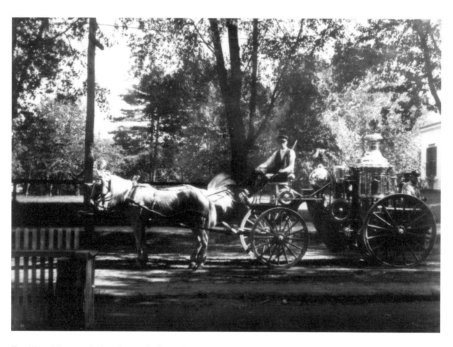

Rockland learned that it needed modern firefighting equipment, so the town purchased this La France steam engine in 1894 for thirty-five hundred dollars. *Courtesy of Dean Sargent.*

Judge George W. Kelley was the first man to sign up to serve as a Rockland firefighter. *Courtesy of Carole Mooney*.

building on Concord Street, and by the time they got back to Vernon Street the building was half consumed.

Mr. Alonzo Perry, in a desperate effort to save some of his goods, ran in and was almost suffocated. They pulled him out in an insensible condition, Town Clerk Ezekiel R. Studley noted in his diary, but were able to revive him.

After this, incendiarism died down for awhile. Perhaps the firebug grew up, or perhaps his attention merely turned to other things in the exciting days of building a new town.

Mr. Lorenzo D. Perkins got a lot of information from the old folks around town who could remember the outstanding events of the past. He also had access to the bound newspaper files in the office of the *Rockland Standard*, files running back to 1854, when the newspaper started as the *Abington Standard*.

Luckily for us, he listed information from the pre-Rockland days of 1854–1873, because the old files burned in the disastrous fire of 1929, which destroyed both the new "old Phoenix" building and a large part of the *Standard* offices and shop behind it on Park Street.

The only old newspaper files that are now available are those that were kept by the town clerk's office beginning with 1875. Bound copies were required in the town office because of official and legal announcements that appeared in the pages. The town clerk's bound files have now been transferred to the Rockland Memorial Library and it is there that this gold mine of information can be studied.

#23: "New Water System Couldn't Save Church," March 17, 1966

The construction of the joint Rockland-Abington water system was begun in 1883 and finished in 1886.

This entailed building and equipping a pumping station at Great Sandy Bottom Pond in Pembroke, together with a dwelling house for the engineer who was on call at all times. It included the erection of a standpipe to which the water could be pumped, and from which it would flow by natural pressure whenever a faucet was opened anywhere in the system. It also meant the laying of 25 miles of pipes and the installation of 182 fire hydrants in the 2 towns, as well as service to the individual houses.

The pumps were started in the middle of January 1887, and the first charges for water began on April 1 of that year.

We think of water as a public utility, as commonplace as the roofs over our heads, but it didn't start that way in Rockland. Even after the service was available the homeowner had to pay for the cost of installing plumbing and tapping into the line. Some men were scandalously slow to take action.

The first person to sign up for service in Rockland was Judge George W. Kelley, who then lived on Reed Street, but at the end of the first year, less than half the homes in the towns had running water installed.

Perhaps it was just as well, for even then, supply could scarcely keep up with demand.

The original plans had called for all three towns of Abington, Rockland and South Abington (now Whitman) to be supplied from this one source, but luckily for Rockland and Abington, Whitman chose not to join in. If that much additional strain had been put on the system, tragedy might have struck sooner than it did.

Two pumps were installed in the pumping station at Great Sandy Bottom and it was claimed that either one, running alone, could keep the standpipe filled to its standard one-hundred-vertical-foot head. But something was wrong with their calculation regarding the amount of water they would be called upon to furnish, for within a very short time the engineer was

Conflagrations

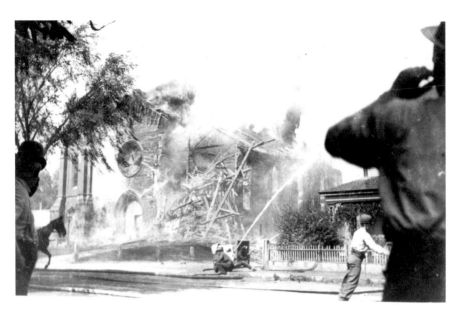

Neither the La France steam engine nor Judge Kelley was ready to stop the Brown Church fire when it raged out of control on July 16, 1890. *Courtesy of the Historical Society of Old Abington.*

requesting pumps with greater capacity. His request was viewed with laxity, however, and nothing was done to increase his potential.

The system was less than three years old when, on July 16, 1890, a sweltering summer's day, the worst fears of the pyrophobes came into being. The old Brown Church caught fire.

Workmen were attempting to burn the paint off the steeple in order to redecorate when the heat penetrated through to the internal timbers and the structure almost burst into spontaneous flames.

The old Brown Church had been built on the northeast corner of Union and Church Streets (the same site as the present church) in 1857, during the height of the popularity of the brownstone style of architecture. It was actually built of wood but in such form as to suggest stone construction. To heighten the effect, the paint, which imitated the color of brownstone, was weighted with sand so as to imitate the texture also.

The sand in the paint conducted the heat from the torches before the workmen realized the situation, and there was no controlling the combustion.

To make bad matters worse, the area had been in the midst of a long drought so everything was tinder dry.

The nozzle-spray fire hoses could not cope with the situation because they immediately depleted the head of water in the standpipe and they had no supplementary pump other than the little hand-powered King Philip.

Desperate calls were made to the surrounding towns for the loan of steam pumps. Valiant responses were made by our neighbors, but at best, the fire was far advanced before the horse-drawn vehicles could arrive. Brockton was a little late because one of the horses dropped dead en route.

With the water from the fire hydrants proving totally inadequate, someone thought of the cisterns, which had been built ten or eleven years earlier and were still kept stocked with water. The King Philip's suction hose was dropped into the tank that was located approximately where Grant's store once stood at 263 Union Street, but that source was soon exhausted, too.

The end of that dreadful day found a blackened area extending five hundred feet to the east on both sides of Church Street, and also found completely exhausted townspeople and an equally exhausted water supply.

Mr. Joshua S. Smith of the *Rockland Standard* wrote later, with admirable restraint, that there was not very much water pressure.

#24: "1890 Fire Took Church, Town Office, Factories, School," March 24, 1966

In Rockland's big fire of July 16, 1890, fourteen buildings were destroyed, totaling a hundred thousand dollars in value at a time when the average home was seldom considered to be worth more than a thousand dollars for tax purposes.

The losses included: the Brown Church; its predecessor, the Old White Church, which had been moved back and converted into a factory; a schoolhouse; the "Lockup"; the home of the late Dr. Underwood, the renowned firefighter (a house then occupied by Deputy Sheriff George Wheeler); two factory buildings, which had been built where the two Blanchard factories had previously been destroyed by fire on Church Street; the Underwood Building; and assorted barns and outbuildings.

Reams could be written on the heroism displayed that day, and the dramatic removal of property from the various buildings.

By far the most important was the saving of the contents of the Underwood Building, which stood on the southern half of the land now occupied by the Rockland Savings Bank. This building housed the Town Offices and the Public Library, as well as the Hartsuff Post, GAR and Chute's Grocery Store.

However, by the next day, the finer side of man's nature had given way to the baser, and accusations and recriminations began to fly. Despite gallant effort on the part of the engineer with his pumps, there simply was not enough water—but everything and everybody was blamed.

Brainerd Cushing, of 112 East Water Street, stated flatly that official negligence constituted a crime and called for an investigation.

George W. Kelley begged for cool and impartial judgment.

A mass meeting was held, but the Board of Water Commissioners, who were on the frying pan of public opinion, chose to ignore it.

The fact of the matter was that the water supply was insufficient not because of mismanagement but because of inadequate facilities.

The records showed an eighty-foot head of water in the standpipe on the night of July 15. When the alarm was given the next day, there were about forty-four vertical feet in the tank. The town had made no provision for additional force for the fire hoses, depending on natural pressure, which would throw a vertical stream forty-five feet high when the standpipe was full.

The two pumps at Big Sandy Pond worked at full tilt during the emergency, but at 7:00 p.m. on the night after the fire, the standpipe contained only two feet of water. Imagine the frustration of a firefighter holding a hose with a little arc of water curving out scarcely higher than his head!

Extravagant use of sprinklers to water lawns on the morning before the fire was also condemned, bringing the blame squarely back on the townspeople themselves. But the fact of the matter was that the two pumps were inadequate to replace the head of water in an emergency.

The results of the matter were: first, the engineers at the pumping station were fired; second, the officials of the Joint Water Board retained their positions; third, larger pumps were ordered; and fourth, the Town of Rockland, after seeing the superior firefighting equipment, which was loaned from neighboring towns, decided to buy a steamer to provide supplementary pressure for their hose lines. A La France steam fire engine was purchased for $3,400 and was delivered on Friday, March 9, 1893.

After the hullabaloo had died down, Ezekiel R. Studley was able to write in a short "History of Rockland," which he provided for Foss's 1892 *Directory of Rockland and Hanover*: "We now have one of the best systems of water supply in the state."

A number of precautions and safety measures were taken over the next seventy-five years, but it wasn't until the 1960s that the entire supply of water for the two towns was brought five miles from Pembroke through one solitary water main. Members of the Joint Water Boards shuddered to think what would happen if unusual pressure had been applied during a similar emergency.

And so it was with a feeling of considerable relief that they saw the deep well near the end of Myers Avenue in Abington functioning, and a large and modernly constructed deep well for recovery of water underground at Fox's Pit would soon be commissioned.

The Birthplace of the Chocolate Chip Cookie

#250: "Whitman's Toll House closes its door," October 7, 1971

We "see by the papers" as the saying goes, that the nationally famous Toll House Restaurant at 362 Bedford Street, Whitman, closed its doors October 9, 1971, and ceased operations.

While it never was in Old Abington, being in that part of East Bridgewater that was combined with the south ward of Old Abington in 1875 to form the town now known as Whitman, it is close enough to justify telling the story in this column.

The main entryway of this restaurant retained the shape of the old Smith House, so-called. The house was built, however (started, that is), by young Jacob Bates in late 1816 or early 1817. Jacob's father died in May 1817, leaving him his estate at the corner of School and Auburn, so he simply stayed on there, letting his own house stand unfinished over on the then new turnpike known as Bedford Street or Route 18.

But two months later, in July, Jacob's sister Polly Bates married Lebbeus Smith. They bought the new property, finished it and settled there to found several generations of Smiths. Hence the former name of the old cottage.

From where the date 1709, which was used in identifying the restaurant, came we have never discovered. The first Bates to arrive in these parts from Weymouth built his home on Adams Street in North Abington in 1706. This is the same year his younger brother, Benjamin, who was to come farther south into what is now Whitman, was born. Cyrus Nash, Old Abington's invaluable early diarist, wrote that brother Benjamin built his house on School Street in 1733. The one-time turnpike on which the restaurant stands was put through in 1804–06. Where the year 1709 could fit into this picture we could not imagine.

The Birthplace of the Chocolate Chip Cookie

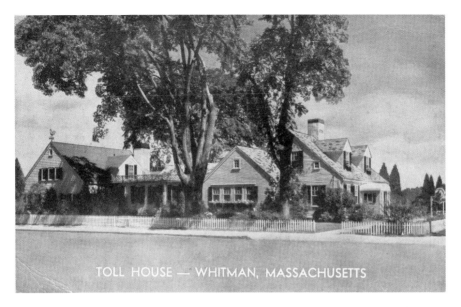

TOLL HOUSE — WHITMAN, MASSACHUSETTS

No sufficient documentation has yet proven that the building that housed the Toll House Restaurant ever served as a tollhouse. *Historical Society of Old Abington.*

The name Toll House is not exactly accurate, either. True, there was a tollgate here at this corner of the turnpike and the "Big Crook Road" as Auburn Street was then called, but the tollhouse was on the opposite side of the street from the Smith residence, next to the little, one-room schoolhouse. It was hardly larger than a coal shed. Its description was remembered by old folks in the town who told this to your Research Reporter before they passed on, some years ago.

The tollgate merely marked the boundary between the fare zones on the turnpike. One could ride only so far without paying an additional toll, even as the Massachusetts turnpike operates today. In fact, this particular crossing was not so much as a coach stop. The 1821 schedule for the Boston–New Bedford run shows that there was a stagecoach stop at Howe's Tavern (now 770 Washington Street, Abington) and then at Sam Browne's Tavern (which stood in front of the present Colony House Nursing Home at 2767 Washington Street, Abington, formerly known as the Hohman florist property). The next stop, going southward, was five miles away, called Cross in Bridgewater, now East Bridgewater. This schedule can be found in the *Old Farmer's Almanac* of that year in the New England Historic Genealogical Society. All of this, plus the flat statement of Bates and Smith descendants that the family never ran an inn, makes utter nonsense of some of the publicity written for the Toll House Restaurant, suggesting that whaling

captains jaunted more than thirty miles northward from New Bedford to partake of the fine food offered here "in the good old days."

But there is no gainsaying the fact that very fine food was offered here by Kenneth and Ruth Wakefield during the 1930s, '40s, '50s and part of the '60s. Their recipe for producing a very superior and nationally known eating place combined experience in the food line with a firm working knowledge of antiques, plus artistic talent, a flair for showmanship, willingness to work hard and long and patience to oversee each and every detail, no matter how small.

They opened, first, in the depths of the 1929 depression, and soon became known as the place to get a fine, full course meal, elegantly served, all for a dollar. People managed to find the dollars and they began flocking here in droves. The dining room, then, was only the front room of the little Cape Cod cottage. The establishment had to grow along with the clientele. Finally, it encompassed the well-known circular "garden room," built around a great tree trunk. The garden room windows looked out on the well-groomed real garden, which was perfection at every season.

The service was elegant, the appointments superb, with real linen and silver and handsome place plates echoing the table decorations. A large hook was provided under each table corner for hanging milady's purse out of the way.

The atmosphere was supposedly American colonial, but the food was nothing less than haute cuisine—and all for modest prices.

Mrs. Wakefield's artistic talents were also evident in the gift shop, which offered unusual "finds" that she and her husband picked up in their trips to every country around the world. Also, especially at holiday times, were the outstanding decorations that Mrs. Wakefield made with her own hands to offer for sale. They were created of the finest material and were very, very different, showing her high quality artistic talent.

The Wakefields are equally well known for their knowledge of antiques, especially in the field of pressed glass. The Glass Museum at Sandwich is greatly indebted to them for their organizational efforts as well as for the loan or gift of many pieces on display there. Mrs. Wakefield told your Research Reporter that the piece photographed for the *Woman's Day* dictionary of Sandwich glass in August 1963 was the Wakefield's own piece, although credited to the museum. The museum had a rule against removing any glass from the building, whereas she was both able and willing to allow the photographer to take their piece to his studio in order to photograph it properly.

The Wakefields retired in 1967 and sold out their property, name and goodwill to the Noel family of New Hampshire. But the restaurant suffered

from lack of the fine Wakefield touch. Substituting a bar for the former gift shop and adding nightclub entertainment on weekends did not suffice to hold the old, or build up a new trade. So the Toll House Restaurant finally closed its doors.

An eating establishment here may not have catered to ships' captains in the whaling days but the Wakefields certainly drew chauffer-driven Cadillacs with license plates from all over New England, regularly depositing mink-laden ladies who sensibly made their reservations well in advance.

Nobody ever really worried about the imaginative date and name for this restaurant. Everybody knew that it was just good promotional technique, and everybody who ever ate there will always remember the days of the Wakefields, which were both "good" and, now, "old."

The Mills of Whitman's East End

413: "The Old Mills of Whitman's East End," May 15, 1975

The East End of what is now Whitman is so interesting and so steeped in history that a large volume could be written on this subject alone. But at the moment we have been asked by one of the teachers in the Whitman schools to straighten out the story of what mill stood where and when in this district, so we shall attempt a short chronology.

1693

The first primitive sawmill was erected here, where the Schumatuscacant River had cut through a ridge, leaving a relatively narrow space where a dam could be raised. That ridge is no longer to be seen. It was lowered when the railroad was put through in 1845. The sawmill was built by John Porter and Joseph Greene, both of whom lived in Weymouth but owned land in what was to become the south part of Old Abington. They erected the mill to saw lumber for people they hoped would buy land and settle here—an early form of real estate promotion. Green's son-in-law John Gurney came here to live and be the first sawmiller, from about 1693 to about 1701. He bought a five-acre "houselot" south of the dam and erected his cottage there. He was the second settler in what is Whitman today, the first having been the Chard brothers of Bicknell's Hill in 1686. Where John Gurney's first cottage stood is unknown today. Perhaps it stood atop the old gravel hill at the west end of the dam, where William Hersey, a later miller, is known to have lived. However, the early Gurney property is generally remembered as being on Plymouth Street, running from Pleasant to Essex. John Gurney had bought this eighty-acre parcel also, and it was later to be settled by his nephews.

The dam for the first sawmill stood just a little north of the present dam, on Hobart's pond, northeast of the corner of the brick building in the 300 block on South Avenue.

The sawmill was known as the Little Comfort Mill. The name may have been brought over from England by the Porter family who came to this country as early as 1633. They may have come from a community in England called Comfort, or a nearby summer community called Little Comfort. Many early American communities were nostalgically named for the towns the immigrants had left in England.

Our Little Comfort Mill was built about the same time that another Porter was building another Little Comfort sawmill near Salem, which gives rise to the theory that the Porters named both.

Little Comfort was never a specific jurisdiction, but it was used to describe the northeastern part of the large, ancient Township of Bridgewater, of which it was a part. The mill was the only landmark they had to describe this corner of Bridgewater. John Harden, who lived in an old cottage near 9 Washington Street, said he lived "at Little Comfort" when he went back to Braintree in 1711 to have his daughter baptized. The Township of (Old) Abington would not be created until the following year. If he had waited until then he could have had his daughter baptized by Reverend Samuel Browne in the Abington church.

1731

Isaac Hobart and four of his neighbors who owned surrounding land joined together to erect a gristmill. The old sawmill was still sawing lumber, so they decided to erect a second installation on the little stream that can still be seen behind the "big chimney," opposite the head of Franklin Street. They induced a millwright to join with them in their partnership, and built a dam that flooded the low gulley all the way back to Plymouth Street. The partners were: Isaac Hobart, Ephraim Spooner (the millwright), Joshua Pratt (a blacksmith), Matthew Pratt, Joseph Gurney and Nathan Gurney. There were then two ponds in the East End—the old 1693 pond with its sawmill and the 1731 pond with its gristmill.

1745

Isaac Hobart decided that if he joined the two ponds together by a canal, he could use the old 1693 pond as a backup supply of water to turn his millwheel in dry seasons and thus grind cornmeal all year round. He built the canal that still shows on the 1830 map, although Isaac Hobart had died in 1775. His stone still stands in Mt. Zion cemetery, where the lettering in style at that time seems to read "JFAAC" for his first name.

1755

Isaac Hobart had been a blacksmith, having learned his trade with John Harden, the blacksmith who took his daughter to Braintree to be baptized. No doubt his son, Aaron, learned the rudiments of metalworking from him, but Aaron took it a step further. He installed a blast furnace at the old Little Comfort site, either in the old sawmill building or in a second building on the same dam. There he cast small hollow ironware such as skillets, bean pots, etc. Apparently an army deserter (British) secured a job with him about 1769 and worked as a bell founder. Aaron's son, Benjamin Hobart (who published his *History of Abington* in 1866) said that the man who taught his father bell casting was named Gillmore, but the Abington town records refer to him as Thomas Gallimore. At any rate, Aaron Hobart and members of his crew were able to teach Paul Revere to cast bells, an industry that was handed down in the Revere family for several generations.

1775

Aaron Hobart contracted with the central committee in Boston (that was heading the Commonwealth's provisional government in the pre-Revolutionary period) to try to cast cannon. We know that he had to rebuild the facilities in his foundry, because he had difficulty in finding new stones for his blast furnace that would stand up under the necessary heat to melt such large quantities of metal. Eventually, after almost putting himself into bankruptcy, he was able to manufacture about a half-dozen cannon, which were used on merchant fishing vessels being used as America's only navy at that time.

1815

Benjamin Hobart, son of Aaron, decided to expand the Hobart business a little further. He began manufacturing tacks at the old gristmill site. He enlarged the facilities during the years and also installed a woolen mill and a fulling mill and dye house for processing the cloth, and altogether was employing so many laborers in his various businesses that he built a boardinghouse, or dormitory, for them on the southwest corner of South Avenue and Franklin Street where an automobile service station now stands. In the meantime, the facilities at the old Little Comfort site had fallen into disuse.

1859

Benjamin Hobart sold his old tack factory to his son-in-law, William H. Dunbar. He stated in his *History of Abington*, on page 286, that at the time

of the transfer he had already installed a steam engine so that he could use either water or steam to drive his machines. This was when the "big chimney" had been built. We have never discovered whether the fire in the new steam plant was the cause, but the old wooden factory building burned in August 1859. Mr. Dunbar immediately rebuilt and continued to manufacture tacks at this site until about 1863.

1864

The new brick tack factory was erected at the old Little Comfort site where the gravel hill had been leveled in 1845. It opened under the name of Dunbar, Hobart & Whidden. In the meantime, the wooden building by the big chimney was converted into a sawmill once again, and boxes for shipping tacks and shoes were manufactured there. By 1879, Dunbar, Hobart & Whidden sold this little box factory to the Attwood Brothers, who manufactured boxes until they moved their business nearer the railroad tracks on the east side of Hobart's Pond.

Lorenzo D. Perkins

The "Memory Picture," which is a small guessing game feature of the *Rockland Standard*, showed a photograph in 1965 of Lorenzo D. Perkins as a young man.

Lorenzo D. Perkins is one of the all-time colorful characters in Rockland's past. He is best remembered, perhaps, for his numerous tales of local history, which were published by the *Standard* over a period of nearly fifty years from the 1860s until the early 1900s. Some of his early articles appeared under such pen names as Ossa, Isaac, Polly Ann, Nero Nash Newcomb and Mrs. Noah Newcomb.

His elaborate Victorian phraseology combined with a wonderfully sympathetic feeling for his fellow men make of him a very endearing figure.

He loved romance. He wrote about Charles Lane buying the little Daniel Bicknell cottage for his bride, Rachel Jenkins:

> *Charles…remarked to her, "Rehoboth—the Lord hath made room for us"…Then there was a transfer of property, an interchange of hearts, the parson's blessing, and Charles and Rachel Lane stood hand in hand.*

About the romantic inclinations of young Jacob Stetson, he wrote:

> *Mr. Stetson's domestic environment was like that of Jewish Jacob when he first sighted Rachel, seven years away from his bed and board—a little lonely. So it was quite natural while his bellows were puffing and blowing his tong-clasped irons to a ruddy glow, he should have his attention called away through the open door by the occasional transit of calico and curls.*

Lorenzo D. Perkins

Martha Campbell stated in Research Reporter column number eight that a misidentified photo of Lorenzo D. Perkins was what sparked her writing career. *Courtesy of the First Congregational Church of Rockland.*

Mr. Perkins was a deeply religious man and constantly made biblical references in his writing. He was a Baptist in his early years, but changed to the Congregational Church, in which he became a deacon and was, for a few years, superintendent of the Sunday school.

He was born in West Hanover in 1836. When he was twenty years old, he came to old East Abington (now Rockland) to work in James F. Bigelow's shoe shop, which stood to the north of the Congregational Church on Union Street. He was employed in the various phases of shoemaking and, after the Civil War, worked in the fitting room of Jenkins Lane & Sons, in the big factory building at the foot of Union Street, which was later enlarged and razed in the 1960s.

Mr. Perkins lived at 291 Market Street, on the corner of Albion. Only he could have written of Market Street that it was "a great thoroughfare, stretching from the Atlantic to the Pacific Ocean."

He wrote of the Rockland cemeteries. He said of the Old Town cemetery: "It is not known who was the first dreamless sleeper laid to rest beneath the roof of this wayside inn." And about the two cemeteries that stand across the road from each other ("new" Mount Pleasant and the old one, then so grown over with weeds):

> *Nowhere on this continent, nor yet in all the earth, is seen another such amazing spectacle as here—a highway between two…cemeteries, on one side of which warm Remembrance strews her tear-dewed flowers, while on the other side, cold Forgetfulness turns unnoting eyes.*

He wrote about the old Boxberry schoolhouse, which stood on Union Street north of 864, and the old schoolhouse that was moved from Market Street to stand on North Liberty Street and be converted into a dwelling. It amused him that the Hatherly Methodist Church stood between these two buildings, and he wrote: "Probably no other temple of worship in the United States is thus situated in regard to any two ancient temples of learning."

Of a year of water shortage in the past, he wrote:

> *During the three months drought in the summer and fall of 1870, when the moon kept changing "in a wet quarter," and forest fires continued breaking out (from all sides), until New England smoked like a vast coal pit, the "Thompson Well" (at 292 Market Street) alone held wet and quenched the thirst of man and beast in all the region round about.*

#9: "More About Lorenzo Perkins,"
November 18, 1965

One of Mr. Lorenzo Perkins's favorite pastimes was talking to the "old folks" and then writing up the tales they told. A particularly favorite source of information was old Mr. Silas Lane, who lived at 261 Market Street. It is from Mr. Perkins's recording of Mr. Lane's recollections that we get so many facts about the early days, especially in the region of Lane's Corner.

Mr. Perkins's phraseology is fascinating, but the wealth of historical facts that he recorded for posterity is invaluable.

One of the great indoor sports among local historians is discovering previously unnoticed newspaper stories by Lorenzo D. Perkins.

Some of his better-known and more important articles that appeared in the *Standard* are: "Old Schoolhouses of East Abington and the Early Teachers" (August 9, 1893); "Ammiel Thompson Place" (July 20, 1894); "Porter Baker Place" (July 27, 1894); "Reuben Loud Place" (August 3, 1894); "Goddard Reed Place" (August 10, 1894); "Lane's Corner" (January 4, January 18 and February 1, 1895); "Market Street Blacksmith Shop" (February 22, 1895); "Jacob Smith Place" (December 10, 1896); and "Old Mount Pleasant" (November 30, 1896).

In addition, another important piece of writing by Mr. Perkins is the text for the souvenir fire department booklet of February 8, 1901.

The folkways about which Mr. Perkins sometimes wrote may not be known to us, but he wrote them down. In so doing, he immortalized his own name, but more important, he preserved for posterity various aspects of the old days that might otherwise have been lost. What we know dies with us unless we find some way to record it.

Of the Yankee thriftiness in preserving expensive gear from the wear and tear of everyday usage, he wrote:

> [Prior to 1812 the people of East Abington attended] *Sunday services at the Congregational church in Abington, walking barefoot across the fields, through the huckleberry bushes on "The Hill," putting on their shoes near the meetinghouse.*

He described the woodworking activities of Charles Lane, who in the early days was first a cooper and later a manufacturer of wooden plows and ladies' busks. In the process, he gave us several more pictures of life in the "good old days."

"The custom in those days," he wrote, "of people making their own butter and salting a year's supply of meat created a large demand for churns and meat barrels, or tubs."

Later, Mr. Lane made plows:

In which he was an expert and had a monopoly of the local trade. In the fall he got his materials of oak, ash and walnut, split the stock for the handles, wet and bent them into proper shape and set them to remain so by keeping them tied down to the shop floor six months.

Plows for breaking up new land were made with beams 12 to 14 feet long, a mouldboard about a yard square covered with iron plate on the side that turned the furrow, an iron colter (i.e., plowshare) a foot in length, an inch thick at the back and hammered to an edge in front, and the point of iron also.

It took from six to eight yoke of oxen—sometimes more—to draw one of these plows through the ground, one man to drive each two yoke, two men to hold the plow handles, one man to hold down the beam, one man walking backwards back of the oxen with a broad axe cutting a groove for the colter, and another man following with a narrow hoe by the furrow in the rear to turn down the sod not left in the right shape by the plow. When one of these teams started ahead something started behind, and New England's "busy hum of industry" was the snapping asunder of obstructing roots and the rattle of upturned stones. Those were labor's golden days; the maker of the plows had had work enough; so did they who used them.

Mr. Perkins's description of the New England cellar, pantry and culinary department are particularly appropriate for the winter season:

[In Lane's cellar were to be seen] bins of potatoes, boxes of turnips and onions, piles of cabbages, tubs of salted meat, barrels of apples, and of cider gallons galore. In his barn great mows of red-top and clover were odorous of praise, while in his granary the corn and rye and oats and beans were suggestive of thankfulness.

[The old kitchen in the Smith house opened into] the pantry where in winter was hung the carcass of a sheep, or calf, a pig, or a quarter of beef which was left to freeze and be cut up for daily use, while herring galore suspended on willow withes—dried mummies of brook and sea—awaited gastronomic sepulture. What piles of steaming goodies were shoveled out of the great brick oven—huge loaves of brown bread, pots and beans and plum puddings and uncounted pies, while from the ashes in the mammoth fire place issued the golden Johnny-cake beneath the overhanging kettle of "biled victuals." What gatherings there were by day around the hospitable board! What social musterings by candle light about the glowing hearth! And when the Angel of Sickness crossed the threshold, over his head, in the attic dispensary, hung bags of roots and herbs enough to smother him.

Bare Knuckles and Bawdy Talk

#10: "Perkins Recorded the Two-Fisted Era, When Men Were 'Laid Out' Regularly," November 25, 1965

When one starts quoting from Lorenzo D. Perkins's writing, it is difficult to stop.

Mr. Perkins once became intrigued with the mixture of military prowess plus erudition in the Lieutenant Elijah Shaw family of upper Salem Street, and he wrote on it. Before quoting from him, we might mention that the ability to battle as well as to cogitate was by no means limited to the male members of this family, for from them sprung Huldah B. Loud, teacher, feminist, newspaper publisher and militant crusader for human rights, especially among the downtrodden.

Perkins expounded:

> *From days antedating the history of the town and since the morning twilight of its tradition, above this ancient domain* [the old Shaw place across the street from 327 Salem Street] *hung the blood-red star of Armageddon, and from its soil as if Cadmus had sewn anew the serpent's teeth, sprang a harvest of stalwart warriors; while in its quiet groves Aristotle found a goodly following, until it has come to pass that of all the farms of all the Abingtons no other has produced so many military and literary personages as this whose century-long procession, in stately ranks, marched from the silent shades of Salem Street to the camp and battle field or to the halls of learning and of legislation.*

In his stories about the big and brawny Smith boys of Liberty Street, Mr. Perkins demonstrates his fascination for physical prowess.

A house-raising [in the early days] *meant…either licking or getting licked, for in those days no building could be properly erected unless somebody was scientifically laid in a horizontal position. One of the latest and most notable occasions of this kind in which David* [Smith] *figures as a wrestler, was when Ludo Poole's house was raised* [at 393] *Union Street, he and Nathan Cushing of Abington having a bout which resulted in victory for neither, Nathan being too strong for David, and David too strong for Nathan.*

In our day it is hardly possible to realize that from fifty to seventy years ago [counting from 1896] *much of the fireside, street and store talk was about who could lick some other fellow, and that if two countrymen met for the first time, each would very likely fall at once to estimating his chances of walloping his new-made acquaintance in a hand-to-hand encounter. Things in dispute that had no possible relation to a wrestling match were often settled that way.*

It seems that David Smith was bitterly opposed to Free Masonry. When he heard that a prominent Mason was scheduled to speak at the Congregational Church, he hiked himself, along with all the other townspeople, to see what was going to happen.

One just never knew what types of shenanigans Rockland's toughs would be up to. *Courtesy of the Historical Society of Old Abington.*

Mr. Perkins wrote:

> *Goddard Reed, who was sexton, would not allow the bell to be rung. A bystander remarked that he would undertake to ring it, whereupon David Smith threw off his coat and vest, rolled up his shirt sleeves, and exclaimed, "If any man takes hold of that bell rope, I will lay him out." The bell did not ring, and no service was held in the church. The people, he said, went to a private home to hear the speaker.*

He told another story about John Smith, brother of David. John, says Mr. Perkins, fancied a likeness between himself and the great and exceedingly popular Daniel Webster.

> *Stage driver Bates of Plymouth, himself a noted athlete, once had John among his passengers to the city. In the evening they visited the barroom of a hotel where the East Abington* [self-designated prototype] *of the "Great Daniel" acquired more and more of a resemblance to him until at the late hour of leaving Mr. Bates thought it best to follow him, unobserved.*
>
> *John had not proceeded far when he was accosted by a policeman who wanted to know where he was going. He received an answer, "About my own business, and if you will attend to your own, there won't be any trouble."*
>
> *Upon this, the officer tried to arrest him. John placed his back to a building, and with one blow of his sledge-like fist laid the officer prostrate. Others came to the assistance of their fallen comrade and in turn were assisted to the recumbent positions until John had five of the brass-buttoned midnight executives of metropolitan ordinances at his feet.*
>
> *The last of the fallen functionaries signaled for more help, when Mr. Bates stepped out of his hiding place from where he had witnessed the unequal fray, and after considerable parleying with policemen who still thought they ought to know John's destination, even if they had to handcuff him in order to learn it, led his Websterian passenger away and the next day brought him out as far as Queen Anne's Corner, from which place he walked home. One sleeve of his new coat was gone, and the garment was nearly torn in pieces by the hooked poles with which the police at that time used to catch criminals when not near enough for seizure by hand.*
>
> *One fall David was mowing salt grass at Strait's Pond when a city gunner fired directly towards him at some wild fowl. David expostulated with him, but in vain and at the second discharge was struck by some of the shot.*
>
> *This was too much for David's good nature and he grappled with the Boston pugilist—for such he was—but was quickly thrown and held*

down. John had seen the whole affair, and hastening forward exclaimed, "Here, David, let me take care of this man." The "champion of the Hub" sprang towards his new antagonist but fell backward beneath a crushing blow, while in old farmer parlance—somewhat harsh for esthetic city ears—John inquired, "What is the matter with you? Your breeching don't seem to be strong enough to hold you up." Twice more the bully was knocked headlong to the ground, and then with humble, satisfied look and air he drew a fluid receptacle from his pocket and meekly said, "Take something."

#12: "Old Town Fighters Including 'John L.,'"
December 16, 1965

John and David Smith, the fighting boys of Liberty Street, once encountered—and bested—the "champion of the Hub," according to Lorenzo D. Perkins.

A description of John's size has come down to us. He stood 6 feet 2 inches tall and weighed 230 pounds. He died in 1874, on December 24, in the ninth month of the lifetime of the Town of Rockland, which was created in March of that year. He was 78 years of age.

No such description of David has been preserved. Presumably he was somewhat smaller, since John is known to have had to come to his assistance on occasion, and he lived fewer years also, dying in 1853 at the age of fifty-four.

Neither man married.

Of the two brothers, John seems to have been the more colorful. He was generally described as a butcher, but he seems to have engaged in other activities as well, including gardening and hostling.

The story goes like this, according to Lorenzo D. Perkins:

[John Smith] *was a butcher by trade and served an apprenticeship in the grim vocation with William Ripley, who lived where Clark Poole now resides* [in 1896; now the Nelson A. Pool House at 417 Liberty Street]. *After he had acquired a thorough knowledge of the calling he formed a partnership with Joseph Reed, but the business proved unprofitable, and, chagrined over the failure which occurred in 1821, he went to Salisbury and from there to the Hudson River towns, passing three years near the Catskill mountains. He next went to Hartford, Conn., and worked three years as gardener and hostler for Lydia H. Sigourney, the authoress.*

When he left her employ to return home she gave him a Bible and a hymn book, the latter containing hymns of her own composing. The Bible

is now [in 1896] *in possession of Herbert H. Arnold...On the flyleaf, in the handwriting of the donor, is the following inscription: "John Smith, Hartford, Dec. 8, 1827—presented to him on his leaving my family, by Mrs. Sigourney."*

During his absence not a word had been heard from him at home and a six year's silence was broken by his lifting the door latch, and [his sister] *Hannah's exclamation, "Why, John!" He resumed his work on the farm, and as butcher and marketman, and things went on much the same as before his protracted non-residence.*

That Bible was given by the late Miss Inez Arnold to the Historical Society of Old Abington and is now in their archives.

Regarding the "champion of the Hub" who was flattened by the Smith boys, a little research into Boston newspapers of the day might produce the name.

One thing is certain: he was not our John L. Sullivan, one-time "champion of the Hub" and first Heavyweight Champion of the World, for John L. was not born until several years after David Smith was dead and gone.

Old Abington claims John Lawrence Sullivan as one of her own because he bought the old Emery farm on Hancock Street and lived out the last days of his life there. He was in town during Old Abington's Bicentennial celebration in 1912 and took part in ceremonies. He died in 1918 of "fatty degeneration of the heart," at the age of fifty-eight.

His homeplace was the brick cottage with stone pillars, now numbered 704 Hancock Street, and is the same farm on which Big Brother Bob Emery of TV fame was born and raised.

John L. Sullivan won the title of Heavyweight Champion of the World in London in 1882, in a bare-knuckle bout. He held his title until 1892, when James J. Corbett, known as "Gentleman Jim," took it from him in the first championship fight under the Marquess of Queensberry rules.

John L. was almost symbolic of the age that preceded scientific boxing, in which two opponents brutally slugged it out round after round until one beat the other into unconsciousness. The winner was often in nearly as bad condition himself.

Fighting was rough, tough, lowbrow and frowned upon by society. It was outlawed in many states and, indeed, in a number of foreign countries. Sullivan's fights were often clandestine with preliminary advertisement going by word of mouth and the crowd gathering as though to witness a cockfight or similar unlawful sports.

His famous seventy-five-round battle with Jake Kilrain under the broiling sun of Richburg near Hattiesburg, Mississippi, on July 8, 1889, was such a

The "Boston Strong Boy" himself, John L. Sullivan, lived out his final years in Abington. *Courtesy of the Dyer Memorial Library.*

fight. The sweat-stained American flag, which he wore around his waist on that day, was given to the Historical Society of Old Abington and is to be seen in the Dyer Memorial Building on Centre Avenue, Abington.

A year earlier, police descended upon a similar illegal exhibition on the estate of Baron Rothschild in Chantilly, France, and John L. spent that night in a French jail.

In his prime, John L. stood 5 feet 10½ inches tall and weighed 180 pounds. His strength was so phenomenal that he became known, almost spontaneously, as the "Boston Strong Boy."

He was the son of a small, wiry father, who emigrated from Tralee, Ireland, at the time of the potato famine, and a mother who is described as a "180-pound giantess."

He began his career in theatres and ended it the same way, but in the meantime scaled heights of international popularity and riches in the world of sports unheard of up to that time.

His capacity for "living it up" right across the board was well known, but he was saved from ending his life in ill-health, poverty, ignominy and bitterness by two people: William Muldoon, his trainer, who pulled him up from physical depths, and later, his second wife, who disapproved of both alcohol and the prize ring.

Temperance Speaker

John L.'s wife was Kate Harkins, his childhood sweetheart. In his late life, John L. actually mounted the platform on the temperance circuit to speak, time and again, against John Barleycorn. When she concluded that his change of heart was both sincere and permanent, Kate agreed to marry him in 1908.

She predeceased him, dying in 1916 of cancer.

Many are the stories told of John L. in Abington, and many are the oldsters who remember the sight of his Irish jaunting cart pulled at a brisk trot around the roads of Old Abington.

Once, as the story goes, he came into one of Rockland's emporiums, large, self-contained and imposing. With no effort on his part he was automatically the center of attention. A small bantam-rooster of a man, who was extremely proud of his financial standing in Rockland, buzzed and bounced around the great John L., preening himself, but exciting no more attention than a bothersome fly. Finally he said, "I guess you don't know who I am. I am the richest man in Rockland! I am worth $500,000!"

"Heck," replied John L. (only he used a word with *l*s in it), "I've spent more than that on booze!"

The Boys of '65

#610: "Veterans' posts established back in the 1860s," May 24, 1979

Back in the 1860s when war still had something of a romantic aura about it, soldiers developed a strong *esprit de corps*, which seemed to continue to the ends of their lives. The servicemen who survived the Civil War to return home perpetuated this camaraderie by organizing themselves into groups known as "posts" (maintaining the army lingo), which were segments of the Grand Army of the Republic, or GAR, as they were commonly called.

McPherson Post No. 73 of Old Abington was organized on December 23, 1868, just three years after the cessation of hostilities in the War Between the States. It was the third post organized in Plymouth County. It took its name from Major General James Birdseye McPherson, under whom many of the local men had served.

The charter members of the post were Franklin P. Harlow of South Abington, Edward P. Reed of North Abington, William B. White of East Abington, Timothy S. Atwood of Centre Abington, Freeman Foster Jr. of Centre Abington, Seth W. Bennett Jr. of Centre Abington, Josiah Soule Jr. of East Abington, Henry L. Cushing of North Abington and Henry B. Peirce of Centre Abington.

As will be noted from the above listing, the four major sections of the town were represented in the original post. However, after the East village and the South village were cut off and incorporated in 1874 and 1875, respectively, two new posts were created along with the new towns as spinoffs from No. 73. They were No. 74 in East Abington (now Rockland) and No. 78 in South Abington (now Whitman).

Post 74 took the name Hartsuff from Major General George L. Hartsuff, commander of the Twenty-third army corps in which 152 local men had

G. A. R. Hall, ABINGTON, Mass.

In the years after the Civil War, surviving soldiers and sailors met in great halls like this one—McPherson Post No. 73, Grand Army of the Republic, at the corner of Washington Street and Central in Abington. *Courtesy of Kate Kelly.*

served. Hartsuff Park, incidentally, got its name from the GAR post, which opened it as a baseball field in the days of the "street-car circuit" when the teams in the area were all connected by the electric cars and used that means of transportation to get to the games. Ah, the good old days, when the phrase "gasoline crunch" would have sounded as alien as words from an unknown foreign tongue.

Hartsuff Post got a new hall when their building was erected on School Street, Rockland, in 1899. By then a ladies' auxiliary was active, known as the Women's Relief Corps No. 137. They pitched in to help raise money to defray the cost of the building. The land cost eight hundred dollars, the architect charged thirty dollars for the plans and the carpenter charged by the cord for lumber handled. All in all, the finished building was insured for fifty-five hundred dollars.

The ladies of the Women's Relief Corps paid for one of the stained-glass windows, partly by taking up penny collections. The fire department donated a large stained-glass window that pictures the then new steam engine, and other groups, businesses and individuals gave the other windows. They are an important feature of the building.

Post No. 78 in what is now Whitman took the name of David A. Russell. They were an active post from the start. It will be remembered that the

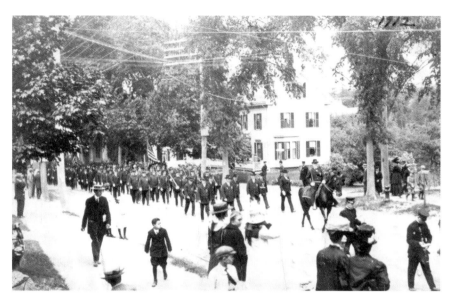

As the years passed, the marching ranks of the Grand Amy of the Republic grew smaller and smaller. *Courtesy of the Historical Society of Old Abington.*

Grand Army Halls like Hartsuff Post No. 74, once home to America's battlefield tales, have emptied out and are struggling for preservation champions in the twenty-first century. *Courtesy of Dean Sargent.*

South Abington Company E, Massachusetts Volunteer Militia, assigned to the fourth regiment, had been the first unit in the commonwealth to sign in on April 16, 1861, the morning after President Abraham Lincoln's call for troops. They were a well-trained unit under their captain (later major), Charles F. Allen of South Abington, and their high interest was sustained after the war. They met in the early days in American Hall in the Bates Block across from the Baptist Church. Later, the post erected its own building on Hayden Avenue. This building was torched by vandals a few years ago, but some of the guns and other memorabilia were saved and are now on exhibit in the Whitman Town Hall.

A picture of the members of Post No. 78, assembled in front of the old Spencer Vining house on the present Catholic corner in Whitman to begin the parade on Decoration Day in 1877, appeared in the *Yesteryears* booklet of 1962 on page eighty.

McPherson Post No. 73 remained in Abington proper. They erected their building in 1896 at 833 Washington Street, on the northeast corner of Central Street. The land had been owned by Colonel Thomas Jefferson Hunt, also a Civil War veteran, and a store run by a man named Blackman had stood on that corner.

As the years went on, and the old-timers succumbed to the grim reaper, Sons of Union Veterans and auxiliaries were organized, but many of the old GAR buildings have now been turned over to the Granges.

This short reminiscence on Civil War veterans cannot be closed without further mention of Henry W. Peirce of Centre Abington. He started as a noncommissioned officer during the war, but later became a captain. He sustained a battlefield injury. After the war, he rose to become assistant adjutant general in the commonwealth and had the responsibility of handling the veterans' pension records. The late Carlos P. Faunce, writing in 1949 on the "Early Officers of the Abington Mutual Fire Insurance Company," said, "Unfortunately a fire destroyed all the records in which the Grand Army men were so vitally interested [but] much of that material was rewritten by him from memory and was of the utmost value."

Mr. Peirce, who lived at 64 Walnut Street, also served as secretary of state for the commonwealth from 1876 to 1891.

A First-Class Citizen

#49: THE RESEARCH REPORTER WRITES
ABOUT DR. GILMAN OSGOOD,
SEPTEMBER 28, 1966

For the past two weeks this column has attempted to recall some of the physicians of Rockland, beginning in its earliest days when it was the eastern part of the Old Town of Abington.

It was planned, from the first, to close this series of thumbnail biographies with the story of Dr. Gilman Osgood. While he was so recently and dynamically alive as to scarcely be called "history," no historical review of medicine in this part of the country could be complete without his inclusion, for he himself was a historian. His interests were, perhaps, equally divided between general medicine, legal medicine, public health and local history.

Gilman Osgood was born in Abington February 26, 1863, the son of Gilman and Isabella (Foster) Osgood. His father was a shoe manufacturer on the southeast corner of Washington and Central Streets.

Young Gilman was a graduate of Abington High School in the class of 1880, one of ten young people who received their diplomas in the spring of that year. He spoke for this class in the reunion of 1930 as follows:

> The class of '80 graduation comprised of Liz Pratt, Mame Flavin, Sadie Nash, Lucia Reed, Helen Soule, Gertie Howard, Mabel Russell, Dan Coughlan, George Lean and myself. We were all sixteen or seventeen years of age.
>
> Seventy percent are living. Average age of the deceased at the time of death, to date, was 41. Expectation of life of surviving members, 78. Total number of years enjoyed, 464.
>
> The girls were renowned for their beauty. Forty percent married within the class and we challenge any class to show a higher percentage. Only 30 percent married outside the Abington High Alumni Association.

Three of us have passed on.

Dan Coughlan was one of the country's leading attorneys. He served Abington as Town Clerk for thirty-three years, directed our big celebration in 1912, and was one of the best friends and supporters the Abington High Alumni Association ever had.

George Lean, whose years numbered thirty-four by the calendar, far exceeded that number as expressed in energy, effort, and good works.

Lucia Reed was about thirty at the time of her death, and some potential home thereby lost a valued exponent.

The rest of us, who survive, are modest and do not wish our good qualities exploited.

Young Osgood was always interested in medicine, and hoped to secure a college degree before entering medical school, but his father suffered financial reverses, and the son had to go to work as a shoe cutter in the factory in the King House (now 349 Washington Street, Abington).

After three years in this trade, he saved up enough to go to New York, were he began his medical training. He entered Belleview Hospital Medical College and graduated with his MD in 1886. He then became associated with King's County Hospital for the Insane on Welfare Island on the East River, New York City, and became assistant superintendent there in 1889 and 1890. After the tragic death of a close friend on the staff of the institution, Dr. Osgood returned to his native town and took over the practice of Dr. Jubal C. Gleason, who died in Rockland in November 1890.

On January 14, 1891, Dr. Osgood married his former classmate, Miss Mabel R. Russell. She was born in Bethel, Maine, but was reared in Abington by her uncle, George L. Richardson, the popular principal of Abington High School and founder of the Abington Alumni Association.

About his general ability, the late Dr. Maurice H. Richardson, famous ambidextrous surgeon of Boston (for whom Richardson House was named) rated Dr. Osgood as the ablest diagnostician of southeastern Massachusetts.

From his experiences in New York, he developed an abiding interest in both legal medicine and mental retardation, serving actively in the Massachusetts Department of Mental Health from 1911 until his death in 1934. And from his devotion to his fellowmen, and to his hometown in particular, sprang his lively interest in public health.

For thirty-six years, from 1898 until his death, he served either as assistant, or as medical examiner for the Second Plymouth District.

One of the more exciting successes among his various crusades was his overcoming of the local opposition in 1903 regarding enforcement of the law requiring preschool vaccination against smallpox.

Dr. Gilman Osgood was more than a doctor—he was a civic leader. *Courtesy of Helen Keeler.*

In the vaccination controversy, a vociferous minority took the stand that "nice" children who came from "good" homes would not be susceptible to "dirty" diseases, and that the introduction of nasty germs into their little bodies was abhorrent. Many parents hung back, awaiting the outcome of public meetings on the subject.

Dr. Osgood, who was a member of the Rockland Board of Health, took his pen in hand and, in a masterly newspaper article, refuted all of the arguments of opponents tracing the history of the disease and naming a number of persons with "royal" or otherwise "blue" blood in their veins who had died of smallpox. He swung public opinion to his side, and of the many vaccinations that he himself administered only one had anything like a "bad arm" as a result. That child was his own daughter.

Another phase of public health that interested him mightily was oral hygiene. Probably an early experience of his own, which he recalled with horror, influenced him in this. He wrote that physicians were the only dentists in his own early days. One day, having a tooth that was giving him trouble, he overtook the local Rockland doctor in his stable.

"Let's see it," said the other doctor. Dr. Osgood sat down on an old chair in the stable, and the other physician examined the tooth. "I don't know but what the d----d pliers will crush it," he said, "but we will try it."

Then he took out his jackknife and cut away the gum to get a better hold. He went to his buggy and pulled out his instruments from under the seat. As he got his grip on the tooth, Dr. Osgood felt the sand and dirt crush against it, but it stood the strain and came out all right. "This incident," wrote Dr. Osgood, "serves to illustrate the character of the methods and the utter disregard of septic conditions in oral surgery common in those days."

#50: "Dr. Gilman Osgood—Part II," October 12, 1966

Dr. Gilman Osgood was a pioneer in the 1910s and 1920s in the field of oral hygiene. He felt that the same scrupulous methods that were followed in the field of surgery should also pertain in the field of dentistry.

At first he was opposed, and even ridiculed, by most dentists and some doctors. However, his results among patients who followed his prescribed treatment provided unanswerable arguments in his favor.

A paper, which he wrote on his findings, was published in 1923 in the *New York Medical Journal* and quoted in the English *Dental Surgeon*. In 1930, he read a paper on the same subject before a joint meeting of two medical societies in New York, and leading physicians of the day remarked that Dr. Osgood was "talking" what they were just beginning to "think."

And always, there was the deep-seated interest in local history, plus a talent in both writing and speaking and also the unique ability to organize.

He organized, and served as first president of the Hatherly Medical Club, which existed from the early 1900s for several decades. Among other things, he compiled biographies of the various doctors who had served, during the years, the district from which the membership of the club was derived. This district stretched from Scituate to Brockton and from Weymouth to Pembroke and Dr. Osgood, incidentally, also recorded much of the history of the towns involved, along with the history of the physicians.

In 1910 he functioned as chairman of the committee on arrangements for the celebration of C. Burleigh Collins's nineteen years on the Rockland Board of Health.

In 1911, he compiled the material published by the Plymouth District Medical Society on the sixtieth anniversary of its founding. This included not only the story of the society, but also biographical sketches on the charter members and technical details regarding current members.

In 1912, for the two-hundredth-birthday celebration of the Old Town of Abington, he wrote the history of the schools and compiled data on all the graduates and teachers of Abington High School since its creation as well

Both Foster and Russell Osgood grew up to serve their country with the U.S. Navy in World War I. *Courtesy of Helen Keeler.*

as the various members of the school committee. Photographs of many of these people were also unearthed, and the whole thing was published in a volume that has become a collector's item.

For this same celebration in 1912, Dr. Osgood also headed the exhibition committee, which put on a show to end all shows with an elaborate collection of records and artifacts dating from the founding of the town.

This exhibition occupied the entire building then housing the Abington High School (present site of the Frolio School), and in connection with the exhibition, the committee published a catalog of the more than two thousand items that were displayed. This catalog is studied by present-day historians like an encyclopedia.

With these and similar experiences in his background, it is easy to understand how Dr. Osgood could work so closely with Miss Marietta Dyer, who wished to leave a fitting memorial to her family in the town of Abington.

The fortune that Miss Dyer inherited had been founded by her uncle, Samuel B. Dyer, an importer in the days before the Civil War. Miss Dyer, working with Attorney William Coughlan and Dr. Osgood, established a trust fund, which would create a combination library and museum.

Dr. Osgood was one of the original trustees set up under her will, and was also the first curator of the collection to which he devoted many hours of time. The historical library, which emphasizes local history and genealogy, was begun by him and today represents one of the rare collections of this type in this part of the country—doubly rare for a town the size of Abington.

He wrote innumerable newspaper releases and was regularly called upon to give the main addresses at such gatherings as GAR encampments and Memorial Day exercises.

Dr. and Mrs. Osgood had five children between the years 1891 and 1904.

Louise R. married Burton Wales and became, herself, the mother of seven children. Their oldest son carried on his grandfather's profession of medicine. Mr. and Mrs. Wales live on Walnut Street, in Abington, and it is to her that your Research Reporter is indebted for more of the material on Dr. Osgood.

Gilman Jr. was a salesman of electrical appliances, and lost his life in an explosion in New York City in 1933.

Russell, of West Hanover, who retired from the vice-presidency of the Rockland Trust Company, was later represented in that institution by his son Freeman, who was trust officer.

Russell's twin brother, Foster, a printing salesman, died as a result of over-exertion in both World Wars I and II.

Helen, who became a psychiatric social service worker, married Burr A. Evans, and lived in New York State.

All five children were graduates of St. Lawrence University in Canton, New York, an institution of which Dr. Osgood's cousin, the Reverend Almon Gunnison, was president. Reverend Almon was the son of Reverend Nathaniel Gunnison of the Abington Universalist church, who established the Mount Vernon Cemetery Association.

Mrs. Wales remembers her father as the busiest man alive. He kept regular office hours and in addition, traveled many miles visiting his large clientele of patients. And he regularly canvassed the countryside and attended auctions in his never-ending search for books to enrich the historical library in the Dyer building. In the early days, he kept carriages and had four horses from which to choose for emergency trips. Later, he purchased Stanley Steamers, in line with the times. Mrs. Wales remembers that he wore out two of them.

Because of his ability as a researcher and his facility with the written word, he was regularly asked to prepare memorials for departed members of the Plymouth District Medical Society.

In addition to the scores and scores of thumbnail biographical sketches and recollections, which he compiled for various publications and addresses, he wrote more elaborate memorials, some of which were published as booklets by the medical society. Among the latter biographies are those (in alphabetical order) of Doctors Wilford G. Brown, Francis M. Collamore, Horatio Franklin Copeland, Henry Waston Dudley, Ebenezer Alden Dyer, John Chisolm Fraser, Jubal C. Gleason, Amasa Elliot Paine, Flavell Shurtleff Thomas and Frank George Wheatley.

Dr. Gilman Osgood died on September 8, 1934, at age seventy-one years, six months and thirteen days, after a period of seven years of gradually failing health.

His death marked the end of a period in the Plymouth District Medical Society, and no official memorial was prepared for him. No one was left with the ability to do justice to the subject.

A Novelist of Rockland

The handsome big cottage that still stands at 306 Liberty Street was built about 1774 or 1775, according to our best educated guess. It was the Daniel Lane Jr. House, presumably built by young Daniel about the time he married Hannah Andrews in 1774.

We wrote about this before in the Research Reporter column No. 248 last September, pointing out that Daniel Jr. wasn't born until five years after the Samuel Green House was built in 1745 near the French-Reed-Studley Pond.

This seemed to be a rather important point to make since somebody went into print with the notion that it was the "oldest house in town." There have, at various times, been many claimants to this dubious honor.

Every interesting-looking old house has its advocates, especially the families who live in them or the real estate salesmen who are trying to sell them.

In the case of the Lane-Pool House at 306, the notion that it was "the oldest" probably sprang from the fact that a picture of it appeared in the *Rockland Standard* in 1929, with a caption that it was so ancient nobody knew how old it really was.

People tend to believe what they see in print. They forget that (first) the editor of that special edition of the newspaper dated September 12, 1929, used only those pictures that were made available to him, and (second) he had to rely on what somebody said because nobody ever has time to do adequate research when trying to meet one of those rush deadlines. So, as we have mentioned before, undue spotlight was focused on one isolated item in our history.

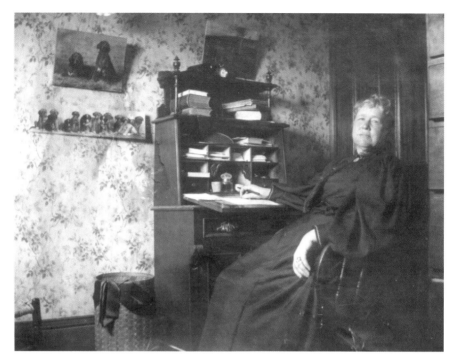

Maria Louise Pool was known to some as a "character," but her eccentricities made her one of the most popular writers of her day. *Courtesy of the Historical Society of Old Abington.*

Actually, in our opinion, acclaim to age is not nearly so important anyhow as people or incidents that may have been associated with a place.

There are a number of interesting events associated with this house. One room here was used as a temporary meeting place for religious services in time of the smallpox epidemic of 1775–76.

The dread disease had struck in the dwelling house of Reverend Samuel Niles in Centre Abington, causing the congregation to temporarily abandon using the church building next door. Therefore, Reverend Niles preached for several Sundays in other parts of the town—in the then new Daniel Lane Jr. house on Liberty Street, and the Hardin House on South Washington Street in present-day Whitman.

Around 1820, give or take a few years, Daniel Lane Jr. served as a justice of the peace, which means that he probably convened JP courts in the main room of this house, since there was no special place for such sessions at that time.

But possibly the most interesting event connected with this house concerns a personality. Miss Maria Louise Pool, the Victorian novelist, was born there. She was a granddaughter of Daniel Lane Jr., her parents having come into possession of the homeplace about the time the old gentleman died in 1831.

Martha Campbell felt that whether the Maria Louise Pool birthplace was the oldest house in town, it was nevertheless worthy of historic preservation. *Courtesy of the Historical Society of Old Abington.*

Late in her life, the authoress built the house next door at 300 Liberty. After Miss Pool's death in 1898, Judge George W. Kelley bought her new house. But it was in the old house at 306 that Maria Louise started writing and, in fact, did most of her work.

She was born on April 3, 1841, according to the town clerk's records; August 20, 1841, according to her gravestone in Mount Pleasant Cemetery, Rockland. Take your pick. She attended the local public schools, but never graduated from high school, nor did she attend college.

She was, in a way, out of step with her times. She was more interested in ecology than in society. She was a great lover of dogs and was given to solitary strolls with her pets, especially in the earliest morning hours.

It is possible that the people of her day thought of her as a "character," but her father apparently saw evidence of her imagination and creative ability, encouraging her and criticizing her output.

She first wrote a series of short stories that were published in the *New York Ledger* newspaper and also in *Harper's Weekly*, using the pseudonym Catherine Ernshaw. Her earliest work under her own name—work that attracted widespread interest—was a series called the "Ransome Letters" published by the *New York Tribune*.

A New York publishing house considered her short writings of sufficiently wide appeal that they collected a number of the individual sketches and put them out as a volume entitled *A Vacation in a Buggy*.

After this she turned to full-length novels, which, while Victorian from our standards today, were considered fresh and witty at that time. Her especial forte was her ability to picture people and day-to-day life in Southeastern Massachusetts in the 1870s and 1880s.

The Historical Society of Old Abington has, in its archives, a set of Miss Pool's work, which, if we are not mistaken, was given to the collection by the late Miss Alice Barstow and Mrs. Eva Packard, who were sisters, and were daughters of Maria Louise's first cousin. There must be around a dozen or so of the volumes, now considered collector's items.

The *Yesteryears* booklist (1962) showed a picture of the authoress at her desk, and the Rockland Memorial Library has an oil portrait of her hanging in the reference room over the fireplace.

It does seem as if some of the colorful aspects of the handsome old cottage at 306 Liberty Street are of more importance than the fact that a picture of it, run-down and needing paint in its earlier days, was published in the local press in 1929.

A write-up of Miss Pool in D. Perry Rice's column, "Folks We Used to Know," in the May 25, 1922 *Rockland Standard* suggests that her old homeplace should be considered a local historical shrine.

Dwelling houses seem to take on personalities almost like living things, and it does seem as if the townspeople should think of this place as an important landmark in the town's history rather than as a house about whose beginnings the newspaper editor in 1929 knew nothing.

The Mighty Schumacastacut and More

One of the responsibilities of a local historical commission is to perpetuate the descriptive names that the old folks used to identify various spots around their town or countryside.

Some of the colorful old names originated with the American Indians. Some examples are: *Manamooskeagin*, which referred to the entire territory of Old Abington and meant "great green place of shaking grass," and the Native American names of two of the local rivers, the *Schumatuscacant*, which runs southward through Centre Abington and meant "beaver stream with stepping-over place," referring to the spot where the ancient Satucket Indian path crossed the river at its narrowest point, and the *Schumacastacut*, which meant "beaver stream always dependable" and still bears the name Beaver Brook on the maps.

We think the *Mattakeeset* may have been a descriptive designation for part of what is now Rockland because this was the early name used for the sawmill on the French-Reed-Studley Pond. A stone mortar, in which Native Americans ground cornmeal with a pestle, was found nearby some years ago by Gideon Studley. He plowed it up in his cornfield where the parking area for Rockland Plaza is now located.

Drinkwater River in present-day West Hanover is said to have been the Anglicized version of the original Native American name *Nannumackeuitt*, which meant that a hollow stem had to be used as a straw when sucking up water from this shallow, sluggish stream.

Some of our local place names go back to the early days of the British Colonies here.

Accord Pond, for example, was given its name by representatives of both Plymouth Colony and Massachusetts Bay Colony, when they met there on

June 16, 1640, and came to an agreement, or accord, that the center of that pond should be one bound on their mutual jurisdictional line. William Bradford, in his *Of Plimoth Plantation*, recorded this in his manuscript on page 232.

Some names came into being through usage by the early settlers.

Poison Bottom in Whitman was descriptive, referring to the lush growth of poison in the strip of bottomland that lay between South Washington and Harvard Streets. The high land at the eastern end of South Avenue, called Rye Hill on the 1962 U.S. Geodetic (Geological) map, was called Tillson's Hill by old-timers after the family by that name that lived there in the mid-1800s. The description of the route of the new road (now Plymouth Street) in 1707 called this rise Bottle Hill—reason unknown, but suggestive.

Cricket Hole referred to what is now Hanover, and Greenbottom was the name attached to the little stream that rises near where the foot of Weymouth Street joins VFW Highway in Rockland and runs southward to become what is now called Cushing's Brook where it flows through a culvert under East Water Street. It is so labeled on Captain James Bates's 1830 map of Old Abington.

Some local names became attached during the early industrial days, such as Project Dale in South Hanover and Lane's Corner at the foot of Rockland Street in Abington at Brockton Avenue.

Many crossings were referred to by the name of the country store that stood on the corner: Pool's Corner at the head of North Avenue on Union Street in Rockland, Harwood's Corner at the present crossing of North Avenue and Route 18 in Abington and Faxon's Corner where Brockton Avenue now starts westward from Washington Street in Abington Centre.

Some names came into use in the youthful jargon of boys growing up in the neighborhood.

Piggery Beach has come to our attention, and is said to have referred to a short stretch of a feeder branch of the Schumatuscacant River, where the feeder flowed through the area now occupied by the old filtration beds near present-day Charles Street. How it got this name is unknown.

The origin of another name that arose through usage by youngsters in early days is known. It is Deke's Hole, where boys swam on hot summer days. This was a relatively deep spot in the Schumatuscacant River, where it flowed alongside present-day Mount Vernon cemetery, down behind Frolio School.

This property came into possession of the Everett Atwood family a few years after the end of World War I, and several decades ago Freeman Atwood broadened the deep end of the old swimming hole. He sold the reclaimed fill. Thus his name became attached to what resulted in a sizeable pond. The original name of Deke's Hole became lost, but not forgotten.

The Mighty Schumacastacut and More

The earlier designation had been used by the boys because the swimming hole was on the back land of Deacon Richard Vining, who was elected to his office in the Congregational Church in 1723, and whose title became a familiar abbreviation.

We feel strongly that the wonderful old place names should be searched out, researched and recorded as a special project before they become lost to posterity. Researchers, today and in the future, need to be able to identify locations they find written into the early records.

We suggest that anybody who knows of an early place name in his or her town get in touch with the local historical commission so that a list can be compiled and the locations indicated on a special map.

Last Stop of the Hanover Branch

Notice has been received that an application has been filed with the Interstate Commerce Commission to abandon what was once the Hanover Branch Railroad, Rockland and West Hanover's only connection with the network of rail service in the rest of the nation.

The Penn Central purchased what remains of the New Haven line (formerly the Old Colony in these parts, and including the Hanover branch) on January 1, 1969.

The Hanover Branch was exactly what the name implies—it was a branch off the trunk of the mainline. It began as seven and two-thirds miles of track branching off from North Abington and projecting out to Hanover Four Corners, with its midsection passing through Rockland, West Hanover and South Hanover.

The Hanover Branch Railroad was almost altogether the child of the late Edward Young Perry of South Hanover. It began life as his brainchild and he literally nursed it, financed it, bossed it, provided business for it and chastised it when necessary.

The Hanover Branch provided the lifeline of transportation for old East Abington's big factories, and also served similar installations all along its length through the various Hanovers. Mr. Perry saw to it that industries were founded and developed to use the transportation and both the railroad and the factories flourished. The businesses he owned or promoted, at least in part, included tack factories in Hanover, the Goodrich shoe factory in Hanover, the Lot Phillips box factory and a sawmill and gristmill at West Hanover and the coal and grain business of Albert Culver, which now specializes in fuel oil in Rockland.

The former E.H. Clapp Rubber Co. of Hanover was perhaps the branch's most important client and the mainstay of its moneymaking freight shipments.

Last Stop of the Hanover Branch

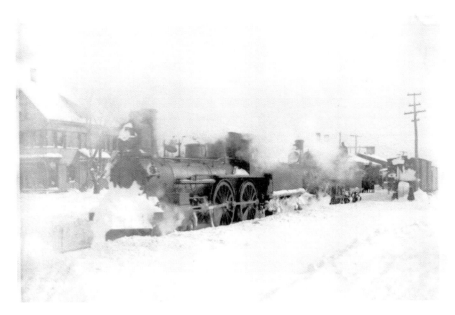

The Hanover Branch of the Old Colony line was a frequent sight in Union Square for more than eighty years. *Courtesy of Carole Mooney.*

Although, like all railroads, its main source of revenue was its freight handling, the branch also furnished facilities for passenger service. So many well-to-do commuters used the branch around the turn of the century to reach the mainline and travel to Boston that the little railroad was referred to, jocularly, as the "bankers' special."

Under the fatherly ministration and close surveillance of Mr. Perry, the branch flourished and for more than twenty years paid regular dividends to its shareholders—an example of what one man's stamina and singleness of purpose can accomplish.

An interesting thing is that the branch originally got off to a shaky start. When the mainline of the Old Colony line was first put through in 1845–46, the idea for a single track branch to Hanover was advanced and a charter was actually secured from the state legislature in April 1846. However, nothing was done to implement the project and the charter expired under its time limit.

In the meantime, however, Mr. Perry had become involved in manufacturing tacks in South Hanover and he could see nothing but advantages to building the branch line to haul local freight. As the Civil War was drawing to a close, he began promoting the idea, even going so far as to personally guarantee nearly $125,000 at 6 percent interest to the backers.

Logically enough, Mr. Perry was elected president of the tiny but important railroad company when it organized in 1864, and he pushed the work to completion. It began service in July 1868.

At first, the Hanover Branch's entire rolling stock consisted of one little double-ended engine and three coaches, all secondhand. The single track had no turnaround facilities at its rail end in Hanover, so the little engine pulled the coaches one way and pushed them back the other.

In time, the line purchased engines of more advanced design and greater power. They were named the Hanover, the Brant Rock and the Spark. The little original engine became the Dummy, and was used to push empty cars back on the "dead-head" run. Various kinds of freight-hauling equipment were also secured in time, and the company furnished employment for a number of local men in its maintenance as well as on its active runs. It met its schedules regularly with Mr. Perry substituting when necessary in all kinds of jobs, from selling tickets to acting as conductor. If he rode as a passenger, even though he was president, he paid his fare.

As time went on and Mr. Perry's finances improved, he took more and more interest in helping his fellow men. He allowed tenants to live in his property rent-free, and he cancelled all carrying charges on money he had out on loan. His will established trust funds to furnish scholarships to help local youths get higher education. Mr. Perry and his wife had only one child, a daughter who died young, and it was as though he took unto himself not only his beloved branch railroad but also almost the entire community to father.

The Old Colony Railroad bought the branch line in 1887, and in 1893 the branch also went along when that railroad became a part of the New York, New Haven and Hartford. Although it is many years since it was in ownership of Mr. Perry and his partners, local old-timers still think of this one-time important feature of the Victorian days as the Hanover Branch.

Mr. Perry died on May 6, 1899, just five months after his wife's death. They had been married sixty-five years. They lived on what is now the northeast corner of Broadway and Myrtle streets, South Hanover. The two-story house still faces the site where Mr. Perry's big tack factory stood until it was finally torn down a dozen or so years ago.

The Railroad Riot
of 1893

#632: "New Haven Railroad built
the North Abington depot,"
October 25, 1979

The North Abington Depot has always been of great interest to the people of Abington. It has also been of personal interest to the people of Rockland and Hanover who commuted to Boston and back, changing trains at this station between the Hanover Branch and the mainline. E.Y. Perry's Hanover Branch had begun service in 1868.

The New Haven Railroad built the depot in 1893–94 and maintained service on the line for two good generations, but by the late 1960s it found itself gradually sinking deeper and deeper in debt. The development of other forms of transportation was squeezing out the rail service. Carrying passengers was never a paying department anyhow, and the company eliminated it on the main line in 1964. Commuters were forced to rely on buses or drive their own automobiles, creating traffic jams and polluting the atmosphere with their exhaust.

Finally, on the verge of bankruptcy, the New Haven turned to the Penn Central Railroad, which was a larger and more nearly solvent corporation, and after clearing the move with the Interstate Commerce Commission, Penn Central took over the stock and services of the New Haven on a ninety-nine-year lease on January 1, 1969.

One of the first orders of business was to close the Hanover Branch, ripping up the tracks from West Hanover to the old end of the line at Hanover Four Corners. A bank has now been built on the corner of Broadway and Route 53 in Hanover where the old Hanover Branch Railroad Station once stood.

The real story of the North Abington Depot begins with the financial panic of 1893, which was a direct outgrowth of a drought of 1890 that

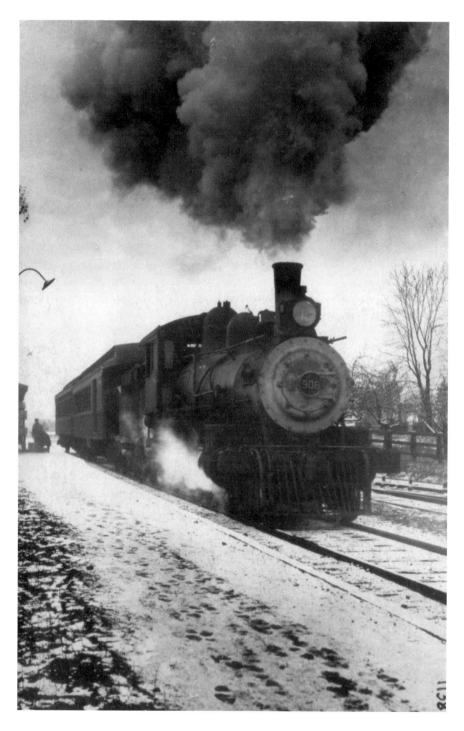

Little did anyone know what troubles the train would cause when it came to town in the middle of the nineteenth century. *Courtesy of the Historical Society of Old Abington.*

ruined the American wheat crop. A revolution in Argentina, following a period of great expansion, also added to the problems. This was during the Cleveland administration when unsound banking policies allowed the government to give reckless financial backing to the railroad.

The panic began when the Reading Railroad Corporation failed, and one big business after another went into bankruptcy.

Everything ground to a halt. Twenty-two thousand miles of railroads were in receivership. Pullman company employees chose this moment to strike.

Men who had held responsible positions were suddenly without jobs, and heads of families took to tramping the roads in search of work. Newspaper called them "Knights of the Road."

The town of Abington fed about 130 tramps in 1893; by 1894 the number had risen to over 1,000. The town tried the procedure of working the transients on the road gangs, which helped recoup the cost of feeding them to some extent. At one time, a nearby town had fed their tramps on crackers and water at the cost of $0.10 a head per day, but Abington never descended quite that low.

By 1896, the cost of this humanitarian gesture on the part of Abington had risen to over five hundred dollars per year, which was no small amount for a town whose gross expenditure was little more than thirty-five thousand dollars per year.

The aftermath of the panic lasted some four years. Abington spent only a hundred dollars or so on feeding the Knights of the Road in 1898.

In the meantime, in the progressing depression, which culminated in "the Panic," the Old Colony Railroad was saved from collapse only by consolidating with the Penn Central.

As of January 1, 1893, the former Old Colony Railroad was to be officially designated as "the Old Colony Division of the Consolidated Railroad," according to Hager & Handy's *History of the Old Colony Railroad*. A meeting of the stockholders was held in Boston and it was so voted by a majority of 87,092.

This was too lengthy and complicated a title for the public to handle, and contemporary newspapers tried to shorten it by calling it simply "the Consolidated," while in other quarters the name "Old Colony" hung on for a year or two. A decision taken by the Supreme Court in May 1894 refers to the line still as the "Old Colony."

But back in July 1893 the *Brockton Enterprise* printed a squib in its "Just Jotted Down" column that said, "When the Old Colony cars are repainted the familiar words will leave the sides, and in their place will appear 'New York, New Haven & Hartford.'"

Perhaps the public became more accustomed to seeing the big new name emblazoned on the rolling stock. But whatever the cause, local

citizens referred to the railroad through Abington merely as the "New Haven," and by this name the line was known from 1893 to 1968—seventy-six years.

By 1979, the railroad line had been under the control of four different entities: the Old Colony railroad, 1844–1893 (forty-nine years); the New Haven, 1893–1968 (seventy-six years); Penn Central, 1969–73 (four years); and the state's MBTA, 1973 to 1979 (six years).

The granite and brownstone North Abington Depot was not erected until after the train service had been "consolidated" with the New Haven, but the Old Colony Corporation was surely involved with it—as we shall see.

#633: "For Want of a Frog a Riot was Born," November 1, 1979

The changeover in control from the Old Colony to the New Haven Railroad was not without its problems. Not only was the New Haven already in somewhat strained financial condition, but they inherited a costly accident at the crossing of the railroad tracks in Brockton. The accident had occurred on one of the important downtown streets, possibly Crescent Street.

The railroad had not cut their rails and inserted a frog, which would allow the streetcars to cross there without having to bump across on the flanges of their wheels. Having to bump up over the railroad tracks was a safety hazard. A streetcar had become derailed in the process at that crossing in Brockton, and a locomotive charging down the track had slammed into it before it could be cleared from the tracks.

As a result of this accident, the railroad was forced to regrade their entire right of way through the downtown section so as to cross above all of the streets. The cost was $1,500,000. The street underpasses are still to be seen in Brockton. The Brockton Police Department now occupies the upper level where the railroad station formerly stood.

This cost was one of the problems that the New Haven inherited. And as a result, the board of directors apparently voted that they would not allow further crossing of their rights of way by streetcar tracks.

Whether the selectmen of Abington were aware of all this is immaterial. The fact is that on May 23, 1893, they granted the Abington & Rockland Street Railway Company permission to lay their tracks along North Avenue. This was to be the link connecting transportation facilities between Abington and Rockland, and the streetcar tracks would have to cross the railroad tracks in order to complete that connection. They notified the New Haven of that permission.

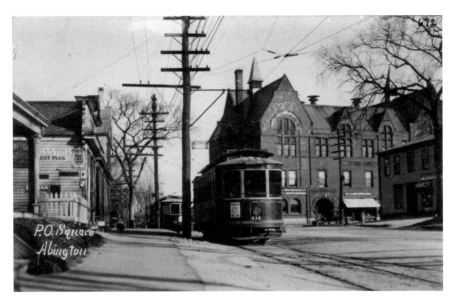

The problems with the trains didn't begin until the streetcars came along. *Courtesy of the Historical Society of Old Abington.*

The New Haven took the stand that it was not their responsibility to assume the accidents that might happen at that crossing, so they filed a bill in equity in the Massachusetts Supreme Court, praying for an injunction restraining the streetcar company from crossing their right of way on North Avenue. A bill in equity is where justice is requested for a situation not covered by law. No law had been enacted as yet regarding streetcar tracks crossing railroad tracks, nor had a requirement that a frog be inserted.

The simple little frog, which was nothing more than a short section of the tracks with grooves cut for the flanges of the wheels to ride in when crossing, never entered into their calculations at the moment. The whole argument, at least on the part of the railroad corporation, was that of avoiding liability if an accident did occur when a streetcar tried to bump up over their tracks.

On Wednesday, June 21, 1893, Judge Marcus Perrin Knowlton of the state's superior court refused to grant the injunction, saying that the streetcar company had received proper permission from the selectmen of Abington and were taking the proper safety precautions required by law and therefore had the right to lay the tracks along North Avenue.

At this point, the New Haven's counsel gave the railroad the wrong advice. He believed that the decision to refuse the injunction was not valid because it had been handed down by a single judge, rather than the full bench sitting

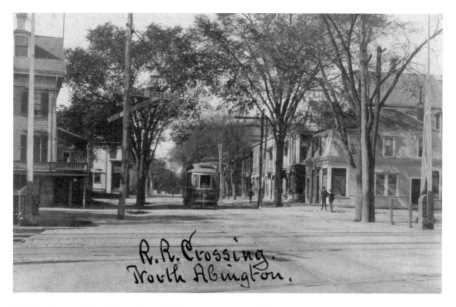

R.R. Crossing.
North Abington.

In fact, it was when the train and the streetcar were about to come together that the rioting began. *Courtesy of the Historical Society of Old Abington.*

in session. And furthermore, he believed that the railroad could prevent the crossing of their right of way by a show of force.

The New Haven's counsel for this segment of their holdings seems to have been Charles F. Choate, former president of the Old Colony Railroad Corporation. His opinion is one indication of the fact that the head of a corporation seldom understood the grass roots situation. Mr. Choate missed the point that the railroad owned no right of way across the public highway. They only had the right to cross it. The citizens of Abington owned the street, and their selectmen were their elected officials who spoke for them. The selectmen had granted the railroad corporation the right to cross North Avenue and they had also granted the Abington & Rockland Street Railway Company the right to lay their tracks along North Avenue. Those tracks would have to cross and it would be the responsibility of the railroad, as first comer, to provide for a safe crossing—in short, to insert a frog—or risk the liability.

But apparently the railroad people did not want the nuisance or the cost of inserting a frog. It is inconceivable that they never thought of it. At any rate, they took Attorney Choate's advice and chose to try to prevent the crossing.

Later, they were also to make the lame excuse that the streetcar company should have secured a positive permission to continue their work and not relied on the negative approach implied in Judge Knowlton's refusal to stop it.

At any rate, the New Haven chose to take Mr. Choate's advice and stand up against the streetcar company—and the Town of Abington—with a show of force.

As the first step in their plan they sent a workforce to Abington to build a spur track, so they said. The *Rockland Standard* of Friday, June 30 said (on the "North Abington" page): "The Old Colony Rail Road have put in a new track across North Avenue to facilitate the business of the Hanover Branch." It will be noted that Reverend Jesse H. Jones, who edited that page, was still using the old name of the railroad. This little dead-end piece, called a "blind" track at the time, seems to have merely led about two hundred feet to the E.P. Reed lumber company, despite Reverend Jones's explanation of it. That workforce was then kept on standby, in South Weymouth. Most of the men were Italian immigrants who apparently accepted the fact that they would have to sleep in the boxcars.

In the meantime, work on laying the streetcar tracks progressed. By Wednesday, July 26 Reverend Jones was able to put into print the fact that the work of the "electric road" was nearing completion. It was moving faster on the east (or Rockland) side of the railroad tracks. On the west side, between Harwood's Corner (crossing of present-day Route 18 and North Avenue), the schedule was slower because the county commissioners had ordered that segment of the street to be widened, a job that hopefully would be completed before the tracks were laid.

#634: "STREETCAR SERVICE STARTED DESPITE PENDING TROUBLE," NOVEMBER 8, 1979

The work of laying the rails and building the streetcar barn at the site of 385 North Avenue progressed steadily.

By the first week in August, the streetcar tracks were within one foot of the railroad tracks on the east side, but were still about one hundred feet away on the west side.

Although the two ends of the track were not yet connected, a big gala opening of the line was held on Tuesday, August 1, in Rockland. Trips were made, beginning about 3:00 p.m. between "the Hill" in Rockland and the railroad crossing on North Avenue in Abington.

In the evening a concert was played by the combined Rockland and Abington brass bands in front of the Sherman House hotel that stood on the northwest corner of Union and Belmont streets. All rides were free that day and twenty-eight hundred people took advantage of the exciting chance to "ride the trolley."

Cars were also plying back and forth from the railroad tracks on that side connecting with the town of Whitman. It was possible to get off the car on one side, walk the one hundred feet and catch a car on the other side to make the connection and complete the trip.

Mrs. Marcus A. Darling of Rockland, wife of the jeweler, was the first passenger to board the car for the exciting ride.

It was reported that some horses were frightened by the clanging of the passing streetcars, but on the whole, there were no untoward incidents, despite the fact that the pubs also did a lively business.

The Rockland side of the streetcar line was then opened for regular business on Thursday, August 3 at 6:00 a.m., and after that first regular day, cars ran at fifteen-minute intervals until late at night. The fare was five cents.

In the meantime, on Wednesday, August 2, streetcar laborers had removed the planking that lay a distance of one foot on either side of the railroad tracks preparatory to laying their rails to butt against those tracks on the east side.

A locomotive was dispatched to North Abington that night and assigned the job of patrolling the crossing to guard against any further activity there by the streetcar people. The streetcar people did no more actual crossing for the time being, but during the next five work days between August 2 and 9, they brought their tracks on through the business district on North Avenue up to that one-foot strip of planking alongside the railroad's tracks on the west side.

Realizing that the streetcar people had every intention of completing their line joining Whitman with Rockland via North Abington, the New Haven then sent a second locomotive to the North Avenue crossing on Friday evening, August 9.

Both locomotives had orders to steam back and forth across North Avenue on guard duty.

Since regular service on the mainline seems not to have been interrupted, it would appear that the locomotives were on a siding or that spur track. Perhaps they were also guarding the Italian laborers who were again brought back to the scene.

This crew of railroad laborers, that later was to be a part of the railroad's "army," hung about with little or nothing to do for a week.

Then on Tuesday, August 15, the New Haven brought in a second carload of "laborers" under the supervision of railroad Detective Christopher T. Bailey, a man known in the locality because he had previously been a marshal in the city of Brockton. This second carload had been being held on standby in South Weymouth.

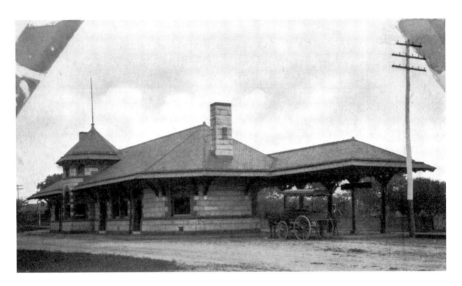

The North Abington Depot, finished in 1894, was a peace offering of sorts from the railroad company that originally fought to keep the streetcar from crossing its tracks. *Courtesy Dyer Memorial Library.*

During that Tuesday night, August 15, the trolley wire was mysteriously cut above the railroad tracks and a sixty-six-foot length was cut out, leaving the two ends dangling onto the street on either side. This meant that the streetcars could progress no farther than the nearest poles, which supported the wire. So, early the next morning, the streetcar people had the two ends raised and tied together with a long rope. Pulleys were used to draw it up tight overhead for the wheels of the trolleys to make contact, allowing the streetcars to come directly to the crossing once more. But this temporary arrangement didn't last long.

Shortly thereafter, one of the patrolling engines pulled one freight car toward the crossing, slowed momentarily, and one of the laborers on top of the car reached up and cut the rope, dropping the end of the trolley wire to the street again.

Fortunately (or rather, unfortunately for the young man) that laborer was a local fellow who was in the employ of the railroad, and he was recognized. His name was Patrick Griffin and he lived on Arch Street. He was known about town as "the Gossoon."

A warrant for his arrest was issued that afternoon and young Griffin was found where he was hiding and he was placed in the little brick lockup on Brighton Street.

Roadmaster Bryant, of the New Haven line, bailed him out, guaranteeing five hundred dollars for his later presence in court.

Young Griffin came to trial for "tampering with the streetcar company's property," but he claimed that he was only acting on orders. He was fined twenty-five dollars nevertheless, which the railroad no doubt paid.

The little brick lockup no longer stands on Brighton Street. It was torn down about 1965–66, after the new police station on Central Street was built, but an interesting use came of its remains. Edward and Alice Frame got hold of the old bricks and used them to erect a most elegant "Chic Sale" at their former summer place on the Gurnet in Plymouth.

The fact that the two ends of the trolley wire were again dangling on the street spurred Major Reed to hang posters offering a hundred dollars "for information that will lead to the detection and conviction of the person or persons who cut our trolley on North Avenue last night." But the culprit was never identified.

#635: "SITUATION BUILDS TO A CLIMAX AT THE CROSSING," NOVEMBER 15, 1979

In describing that dramatic Wednesday, August 16, 1893, we must rely largely on the contemporary reports of the journalists covering the story. Boston papers—the *Globe*, *Herald*, *Post*, *Journal* and so on—sent reporters to the site, and, of course, the *Quincy Ledger*, *Brockton Enterprise* and the *Rockland Standard* (weekly) also had much coverage during the episode.

The stories do not always exactly coincide. They disagree as to size of the crowds that gathered and the exact chronology of the events during the day are reported somewhat differently, but by coordinating the various versions we can come up with a fair idea of what really happened. In fact, we may be able to piece together a more accurate version than could the reporters who were there that day, because it was such a disorganized melee and the action came in such surges and at different spots that it was virtually impossible for any one person to be everywhere and see everything at the same time.

The directors of the streetcar company had met with President E.P. Reed in his home on the evening of Tuesday, August 15. They decided that they would seek an injunction against the railroad if the latter attempted to prevent the laying of the streetcar tracks the next day.

Some officials of the railroad company had also been in town overnight, staying at the Culver House, the then hotel at the southwest corner of the street crossing, a building now known locally as housing "the Cellar," a beer parlor.

It was evident that trouble was brewing. The tension of excitement filled the air and spread like wildfire. Men began gathering from near and far,

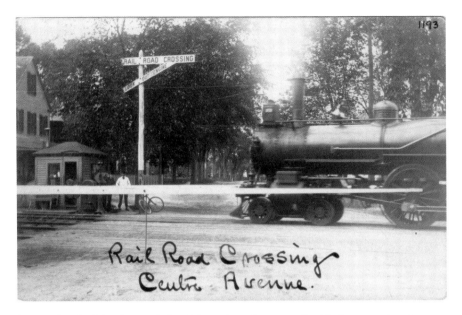

Eventually, all of the dust settled and the train and streetcar lived in harmony, but there was to be bloodshed first. *Courtesy of the Historical Society of Old Abington.*

many riding the very streetcars that were the basis of the trouble. The cars tried to maintain their regular fifteen-minute schedule, coming as close as they could to the crossing on either side. They couldn't come all the way until the two ends of the trolley wire were raised once more, but the excited passengers hopped off the cars on each side and ran the half block or so to join the fast-gathering crowd.

"The town looked like a city for a couple of hours," commented the early edition of the *Brockton Enterprise* on the following morning, August 16.

When it became clear that lightning was going to develop that night, the crowd—estimated at a thousand people (some said two thousand)—dispersed.

Local residents returned to their own homes, the railroad officials retired in the Culver House and the railroad laborers bedded down as best they could in the open air or in the boxcars.

The morning of Wednesday, August 16, dawned bright and clear, with a promise of heat during the day.

By 8:00 a.m., the New Haven's "labor crew," mostly Italian immigrants, was ranged along the railroad track, and when Major E.P. Reed walked over from his home on the northeast corner of North Avenue and Adams Street, the Italians saluted him. He approached their boss, Roadmaster Bryant.

He said, "We want to begin laying out streetcar tracks in five minutes."

Roadmaster Bryant said, "Won't you wait until we can notify our Superintendent Sanborn so that he can discuss the matter further with you?"

Major Reed acquiesced, and Judge George Kelley advised that the streetcar's labor crew be moved back some half mile toward Rockland, where they stayed the better part of the day.

It is interesting to note that, while the building of the streetcar line was the bone of contention, those men never took part in the ensuing fight. The confrontation was between the railroad and the officials of the Town of Abington.

#636: "RAILROAD REFUSED TO HEED WARNING," NOVEMBER 22, 1979

After Roadmaster Bryant secured a postponement of activities, he stepped over to the old wooden railway station on the south side of North Avenue and telegraphed Superintendent Sanborn in Boston, using the railroad's own telegraph wire.

Upon receipt of Bryant's message Sanborn hurriedly scoured the South Boston yards for able-bodied "workmen," ordered a special train and arrived in Abington with his fifty additional "troops" by about 10:00 a.m.

When Major Reed saw them arrive, he realized that a postponement had not eased the tension and he sent several streetcar representatives, including Judge Kelley, by train on the 11:10 bound for Boston. They had orders to secure the injunction that they had voted the preceding night prohibiting further trouble by the railroad men.

By about 11:30 a.m. Superintendent Sanborn had assembled all his men, by then swelled to 250, gathered all their knives or other weapons from them and explained to them that they were there to take up the streetcar's tracks within the 66-foot strip that the railroad considered their right of way across North Avenue.

He then declared lunch hour, but left a small contingent to guard the crossing.

By the time that the lunch hour had come to an end, another special train steamed into North Abington, having come from Middleboro via South Braintree, bringing another one hundred "laborers." The men said later that they had been under the impression when they were recruited that they were to clean up after a bad wreck, not engage in a battle.

About 1:00 p.m. the officials of the town lined up across North Avenue in front of the Culver House, facing the railroad tracks. In front were the

selectmen, the constables and special police, and the fire chief-highway commissioner. Behind them was a fast-growing crowd of excited onlookers, most of whom had, no doubt, also been there the night before.

Ranged along the railroad tracks were the New Haven's men, by then some 350 strong. Superintendent Sanborn had each member of his "army" with a pick, a shovel or an axe. In clear and ringing tones he ordered the crews under Bryant, Bailey, Frazier and Boylen to start digging up the rails within what he considered to be the railroad's 66-foot right of way on both sides of their tracks. He had drawn lines across the street, spanning the distance between the gates that were used to block the traffic on each side while a train went by.

But right there was the crux of the immediate problem. The railroad men took the attitude that they owned the sixty-six-foot strip, whereas the town officials stated that the entire street was a public highway, owned by the people of the town. All of the street—up to and between the tracks on either side— the whole thing was owned by the people who merely suffered the tracks to cross it. In short, the railroad owned no right of way on the highway—they only had a right to cross. They never seemed to understand this point.

Augustus H. Wright stepped forward and identified himself as the highway commissioner and warned the railroad men that they touched the town's public highway at their peril. Officers Hollis and Russell ordered them to heed Mr. Wright's advice.

Selectman Richardson then ordered Sanborn to redirect the railroad laborers toward removing their recently laid spur track, which they had built across the highway without permission. He said, "Take up that track or I'll have it removed by our highway commissioner's men."

The railroad's crew bosses paused to hear Sanborn's reply to that. He cried out to them, "Keep your men doing what they were told to do!"

Then Sheriff Cushman, Officer Russell and Highway Commissioner Wright stepped forward and reiterated the legal warning.

The railroad men stopped work again, and Sanborn paid no heed and reordered them forward.

At this point, the rapidly enlarging crowd of local men began hooting, making catcalls, shaking their fists and showing evidence of charging down on the Italians.

Sensing that the crowd was getting out of hand, Deputy Sheriff Cushman, an arthritic man of some seventy-odd years, painfully mounted a pile of crossties with his cane in his hand, according to tradition, and read the Riot Act. "You have no authority here!" he cried. "I call on you in the name of the Commonwealth to disperse quietly and return to your own homes or where you came from!" Someone knocked his cane from under him and he toppled, luckily caught by helping hands before he hit the ground.

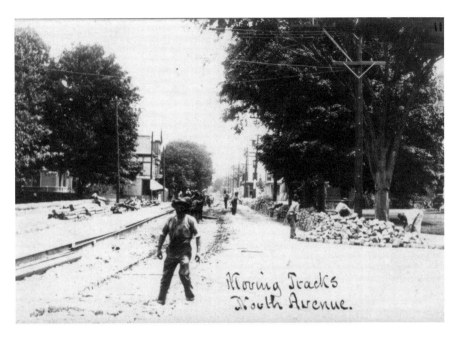

Many of the employees of the railroad line became combatants in the North Abington Riot of 1893. *Courtesy of the Historical Society of Old Abington.*

Police Chief Russell stood with his foot on a heavy crosstie, which the railroad men had dragged athwart the streetcar tracks alongside their westernmost rail. The railroad's Roadmaster Bryant took hold of the end of the beam to remove it. Russell, who was a big heavy man, told Bryant he was under arrest.

Christopher Bailey, the railroad detective, came to Bryant's assistance, and jumped onto big officer Russell's back and could not be dislodged. He began raining blows on his head with a billy.

C.A. Glover, a bystander, finally pulled Bailey off. Russell then started Bryant toward the lockup. Officer Woodward, assisted by Glover, placed detective Bailey also under arrest and the whole group started marching the railroad officials toward the little brick lockup on Brighton Street.

#637: "Fire hose used in vain attempt to quell the riot,"
November 29, 1979

When the town police started toward the lockup with the railroad men in custody, a big segment of the crowd followed along behind, hooting and hollering.

But before they had turned the corner, someone ran up saying that the Italians were killing Officer Hollis. Russell turned Bryant over to James Skehan and began backtracking, making his way through the crowd to get to the aid of Hollis.

The crowd began to realize that the center of action had shifted and they, too, about-faced.

Hollis was down with a deep cut in the side of his head and the Italians were kicking him where he lay.

Russell plunged in and someone cut him across the back with the edge of a shovel while another one sunk the point of a pick into his loin.

Dr. William H. Greeley, of Church Hill in the Centre, had been called and had set up a temporary hospital in the little wooden railroad station. He was assisted by young Dr. Richard B. Rand of Adams Street. They began doing a rushing business, sewing up cuts and bandaging bruises.

Railroad Superintendent Sanborn was knocked down by a highway employee. The Italians rushed to his support with a wild swinging of picks and shovels. Men would fall out of the crowd and stagger over to the sidewalk, groaning and bleeding. Some would be carried off to the doctors; others would catch their breath and plunge back into the fray.

Despite all the efforts to deter him, Superintendent Sanborn was determined to rip up the streetcar tracks, as he had been ordered to do so. In the midst of the disorganized battle, he pulled as many of his men as he could out of the melee and ordered them back to digging in an effort to remove those tracks.

This was too much for the local people. They began pelting rocks at the railroad laborers, who in turn charged back at the local men with picks lifted and shovels "spinning around their heads like pinwheels," as Attorney Buckley later described the scene.

Tradition has it that the selectmen, perhaps with County Commissioner Jedediah Dwelly, who was present, were directing the town's forces from the second-floor balcony that then ran the full length of the Culver House on the railroad side. However this seems doubtful since the town's forces were a howling mob quite out of control.

Realizing that some drastic action would have to be taken to stop the railroad men, Selectman Richardson asked Fire Chief Wright to call out the fire hoses. The chief rang the alarm and the men of Hose House No. 2, just around the corner next door to the lockup, responded. They pulled the two hose reels by hand to the hydrant at the corner of North Avenue and Brighton Street where Bemis Pharmacy is now located.

Mr. Wright himself turned on the water with a heavy hydrant wrench.

The railroad's men fell back temporarily before the powerful stream of water playing on them with great accuracy.

To get some relief, Superintendent Sanborn ordered the crossing guard's shack upturned and used as a shield. Then the railroad forces divided into two parts and began approaching the hosemen from two sides, raining stones on them as they came. Fireman Calvin L. Baker fought bravely to protect the hose as the Italians descended on him.

Soon somebody turned up one of the heavy stoneboats that had been used to drag up paving stones for the streetcar company's work, and the firemen tried to take shelter from the missiles behind it. But one Italian got behind the hosemen and aimed a blow with his axe at Warren White's head. A quick reflex by Glover, who was standing next to him, deflected the blow and saved White's life.

Superintendent Sanborn and a couple of his men got to the hose and severed it with blows of their pickaxes. Some said later that Sanborn carried the nozzle away.

It was about this time that a photographer named Albert A. Haskell, who had a little shop to the northeast of the battle scene, skipped across the street to the second floor of the E.P. Reed Lumber Company's office building and took the important pictures of the scene below. Those pictures were developed in jig time and were carried by alert reporters to the Boston newspaper offices where they, together with descriptions given by the reporters, became the basis for line drawings that appeared in the newspapers the next day and days following.

One of Mr. Haskell's pictures, which was still extant locally, was enlarged by Everett Slayter in 1976 for use by the Save the North Abington Depot Association in their fundraising activities. His enlargement is on display in the Dyer Memorial Library building in Abington Centre.

#638: "THE RIOT RAGED FOR ONLY AN HOUR AND A HALF," DECEMBER 6, 1979

It was about 2:00 p.m. when the two big shoe factories that stood nearby blew their steam whistles and let their employees out to reinforce the town's men. The factories were the M.N. Arnold brick building that still faces Arnold Park and L.A. Crossett's, known as the New England Art building on Railroad Street.

The battle suddenly swelled to over two thousand combatants. Other men poured in, riding the very electric cars that were the bone of contention.

This was the hottest part of the battle. Everything moveable was used as a weapon—paving stones, wooden planks and billets, picks and shovels, axes—everything Fire Chief Wright piled about himself with the heavy

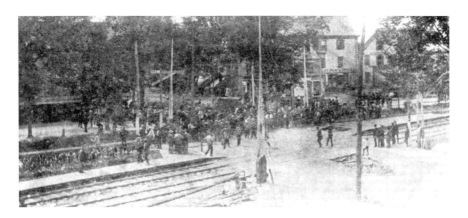

With pickaxes, shovels, knives and even guns, the townsfolk battled the railroad's troops in an hour and a half of uncontrolled combat in the streets. *Courtesy of the Dyer Memorial Library*.

hydrant wrench, which he still had in his hand. He barely escaped with his life when a railroad man attacked him from the rear with an axe. George Jackson saw it and deflected the blow in midair, according to his friend Walter Raymond, who reported it later.

Blows rained, and men dodged as stones were hurled through the plate glass windows of the post office behind them. Some of the railroad gang got the odd idea that a town official had taken refuge there and, being foreigners and hating any form of government, they systematically attempted to break out all of the plate glass by hurling paving stones through it. One grazed the postmistress who cowered in fear. Fragments of that quarter-inch plate glass are in the Dyer Memorial Library's museum on Centre Avenue in Abington.

With their fire hose—their main weapon—incapacitated, the town crowd began to fall back. The railroad men, still led by Superintendent Sanborn, were plainly on the offensive.

Some of the Italians began ranging around the edge of the crowd, seeking new targets. One innocent bystander on the sidewalk in front of Clark's store was stunned by a rock hurled at his head.

Something would have to be done to stop the crazed fighters.

Officer Russell pulled out his gun and fired into the air. The railroad men ignored it. Then he fired into the oncoming throng and one wild shot caught James Renehan of South Boston in the chest. Renehan was carried to the doctors in the little wooden railroad station until he could be taken by train to Massachusetts General Hospital in Boston.

In a momentary lull caused by the realization that men had been shot, Honorable Henry B. Peirce caught the attention of the crowd and

announced that he had information that the Superior Court had granted the streetcar company's request for an injunction.

It was 2:30 p.m.

Sanborn called his men and regrouped them back by the freight cars. He had received a telegram by way of the New Haven's wires. It read:

> *We are advised that the superior court, Judge Bond, has issued an injunction restraining us from further delaying the crossing of our tracks by the electric railroad at North Abington. This relieves us from responsibility, the court assuming it, therefore you will withdraw all opposition to the creation of the grade crossing. You are at liberty to furnish a copy of this to anyone interested, (signed) E.G. Allen, General Superintendent.*

The riot was over. It had lasted only an hour and a half.

In the meantime, one of the reporters went around the corner to Brighton Street and interviewed Bryant and Bailey in the little lockup. They were still in the narrow cell that was hardly big enough for one man. They said that the crowded quarters weren't bothering them as much as the fear that they might be forgotten and have to go hungry. They asked the reporter if he would bring them something to eat if they were still there at suppertime.

The 4:25 p.m. train from Boston arrived on time, bringing the streetcar directors and Judge Kelley carrying the injunction they had gotten from the Superior Court.

Also on the train was Attorney Charles F. Choate, counsel for the Old Colony division of the railroad. He and Judge Kelley argued during the whole trip of something less than an hour as to where the responsibility for the riot lay. The railroad men had never accepted the local laws regarding sovereignty of the people as to the ownership and control of their public highways.

Chief Wade of the state police was also on the 4:25 with ten of his men. He brought a warrant for the arrest of Superintendent Sanborn, but before the latter could be taken to the already crowded lockup, Mr. E.C. Allen himself arrived by special train.

Mr. Allen, together with local shore manufacturer Moses N. Arnold put up bail and all three railroad men—Sanborn, Bryant and Bailey—were released.

The state police dispersed the crowd, the railroad men were loaded onto their train and they departed, and by 5:30 p.m. the streetcar company's labor crew was brought back to the crossing to finish laying their tracks up to, and between, the New Haven's rails. Nothing was said about a frog, but no underpass has ever been built in North Abington and we can only believe that the railroad corporation installed that simple piece of mechanism soon thereafter.

One waggish reporter commented, "The state police are doing nothing. All the injured are doing well."

So ended Wednesday, August 16, 1893, the day of the famous North Abington Riot—a confrontation that the late Attorney William D. Coughlan (nephew of the town counsel of 1893) called "the strangest battle ever fought in the Commonwealth of Massachusetts."

Visit us at
www.historypress.net